Lisa Milroy

TATE

This catalogue is published to accompany the exhibition

Lisa Milroy

Tate Liverpool
19 January – 18 March 2001

Exhibition supported by an anonymous gift in recognition of
the contribution that Lewis Biggs has made to Tate Liverpool.

Cover:
Lisa Milroy, *Tyres* (detail), 1988, oil on canvas, 2210 × 3657mm

Inside cover:
Lisa Milroy, *Flowers* (detail), 2000, acrylic on polyester, 2030 × 13000mm

ISBN 1-85437-343-9

A catalogue record for this publication is available from the British Library

Published by order of the Trustees of the Tate Gallery 2001
Tate Gallery Publishing Limited, Millbank, London, SW1P 4RG

Copyright © Tate Gallery and the authors 2001

All images © Lisa Milroy, courtesy Waddington Galleries, London

Photography: Gareth Winters, Rechard Learoyd, Marc Domage

Designed by Herman Lelie
Typeset by Stefania Bonelli
Production coordinated by Uwe Kraus GmbH
Printed in Italy

Preface

Tate first acquired a painting by Lisa Milroy in 1988 since when we have added five more by purchase and gift. It is therefore a great pleasure to be able to introduce what is the most significant exhibition of her paintings to date. It is always exciting to see the work of an artist develop before one's eyes, and this has certainly been the case during the realisation of this exhibition, for Milroy was asked to make a show for us at a time when her work was undergoing significant change. During the past year she has used more of a gestural form of expression to make complex works which depict thoughts, memories and narratives in shifting space. This exhibition provides an opportunity to witness the development of her work over the past two decades and to trace the ideas which have shaped her current practice.

For this exhibition, the paintings are presented in groups rather than chronologically, to enable the themes within the work to resonate. Since her paintings from the 1980s depicting collections of quite ordinary objects often against a plain background, Milroy has broadened her subject matter to include individuals or groups of people, urban or natural vistas, and, more recently, a less tangible substance: thoughts. Whatever the subject or method of painting, Milroy's work contemplates the nature of representation –the translation of mental and physical imagery into the material languages of paint.

Published on the occasion of the exhibition at Tate Liverpool, this book comprehensively charts Lisa Milroy's career for the first time. Unlike the thematic structure of the exhibition, the catalogue follows the chronological development of the work and acts as a visual lexicon of her painting and ideas. I would like to thank designer Herman Lelie for having worked closely with Lisa to realise this aim. The book also includes three newly-commissioned and insightful essays by Fiona Bradley, Jean-Pierre Criqui and Lewis Biggs. Lewis, former Director of Tate Liverpool, has supported the exhibition from the outset and I would like to thank him for his continued support of the Gallery and its programme.

In making the show, Tate Liverpool is indebted to the private and public collectors, individually credited in the list of illustrations, who have generously lent their paintings and their support. Our appreciation also goes to Hester van Roijen and staff at the Waddington Galleries, and to Jennifer Flay and Luis Campaña for their assistance.

But mostly, our thanks go to Lisa Milroy for her commitment to and enthusiasm for all aspects of the exhibition and the catalogue.

Nicholas Serota
Director
Tate

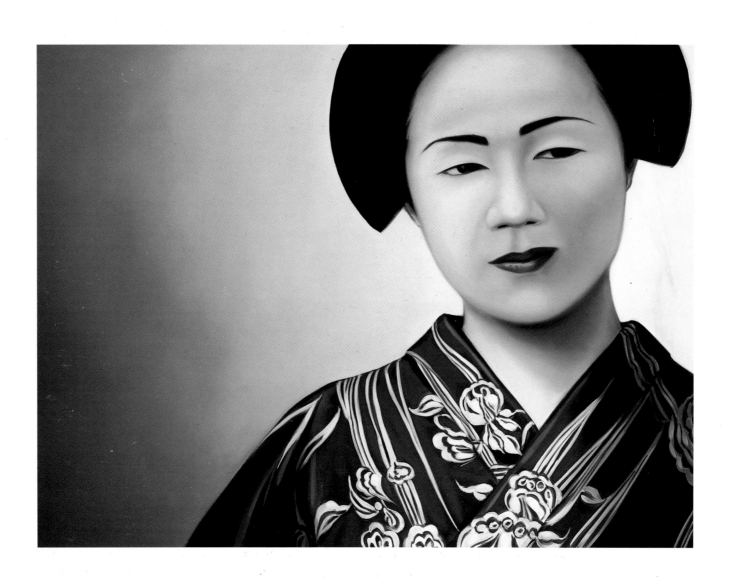

1 **Student Geisha** 1999

Lisa Milroy
Lewis Biggs

The Studio

On the corner of two streets in East London, near Bethnal Green and the Columbia Road Flower Market, sits an unprepossessing red brick building of three storeys, steel mesh at the windows, the door behind a sliding screen of iron bars. After the welcome of bolts drawn back and keys grinding in locks, step over the threshold, turn right through a second door and you are in another world, white painted and suffused with light.

You are in a large irregularly-shaped room, partially divided and on two levels. First, a sofa, sink, books stacked on industrial shelving, cassette player, a cardboard box rummage-full of paint-patched cassettes. Canvases stacked against the walls, heaped images on scraps of paper. Up a step. Paint mixed directly onto a big sheet of glass, supported on trestles, its surface crowded by pots full of paint and brushes. One painting in progress, a handful of others face the wall. Floor, walls, ceiling are all painted white, the light gleaming through whited-out glazing all along the top of one shop-front style wall.

Through these windows drift the insistent sounds of the playground across the street, invisible through the muted windows. The murmurs and cries of mothers and children, the tease and curse of teenagers, are balanced by the music on the cassette machine, but the physical presence of the studio seems defined by its relation to the playground. For all that the studio is suffused with these hard-nosed noises of life-as-it-is-lived, somehow it creates its own emotional space, vulnerable but proudly apart. This is the space where the magic is infused into Lisa Milroy's paintings: they seem to be what we know, but they are always apart, belong elsewhere.

Magic

How is this magic transformation (of what we think we know into something disconcertingly unknowable) achieved? Look at one of the paintings, and it provokes uncertainty. The more paintings you see, the less certain you are as to how you should look.

Lisa Milroy is an artist for whom the craft of painting matters. No – more than that, she loves the act of painting and the way in which paint can speak to us in the way that nothing else does. She can say everything she wants to say through the medium of paint, partly because much of what she wants to say is inseparable from the heightened perception (and heightened emotion) that accompanies the act of painting and of looking at paintings. I must stress, these are not pictures but paintings. They are not pictures 'of' something, they do not 'represent' anything, and their meaning is given them only through their making.

This is a position that we have learnt to accept – or at least to understand – in relation to abstract painting. It is still difficult, however, when presented with a painted image that we have no difficulty in recognising as belonging to the world of not-paintings, of circumstantial experience, to understand that this painted image is entirely uncircumstantial. Lisa Milroy's

are abstract paintings that use images as freely as some other abstract paintings might use colours and shapes. They make no promise, project nowhere else, lead nowhere but back to the painting. The transformation of the image they make is a magic sleight of hand belonging to the act of painting. The melon or tea bowl we see is only paint. *Ceci n'est pas un pipe*.

All images are born in the brain, belong to the world of the imagination before they ever find a place in the world of sensate objects. A perception is no more than that: what we see. By the time we have formed an image out of what we see, it is already a concept, removed from materiality. Lisa Milroy's aim (and this places her in the tradition of the sensual painting of Velázquez, Chardin or Manet) is to use paint to return an image (concept) to its material, voluptuous presence, capable of producing an emotional reaction, not just an intellectual response to a percept-concept. Her images always belong first to the imagination, as mental, magic constructs, not to the circumstantial world. For her, the craft of painting is not a convenience for distributing a concept (in the way that many artists using photography or text, for instance, use their media), but is itself the means of discovering or creating the emotional force of an image. So a painting of a Japanese sweet is not there to tell us what a sweet looks like, but what it feels like to be in the presence of a sweet.

One way of thinking of this is to see painting as translation (the translation of an image, not the translation of a thing). An image has a form as a drawing, a photograph, a print, as words, or maybe just a shape in your head. If an artist says she is concerned simply with the visual qualities of objects (i.e. images) and their conveyance in paint, it is nevertheless a complicated business. Translating that image into the language of paint (vocabulary, syntax, rhythm) is as challenging and creative as translating from, shall we say, French into English. It can be a literal (conceptual) translation, or it can be made to carry the full gutsiness of the culture into which it is being translated.

In Lisa Milroy's case, the process of translation takes the form of starting with an image (its source is unimportant, although clearly the choice matters) and beginning to work that image across the whole surface of the canvas, in paint, with only the most sketchy of preliminary drawing. In her studio, she keeps heaps of images torn from magazines and books and drawers full of her own photo snapshots, none of it with any order or categorisation. She does, of course, make drawings (but not to 'square up' onto the canvas) including drawings of images to be recreated in paint. She has in the past made use of an epidiascope, but again, only as a quick means of getting started. Recently, she has also used her own memories as a source of imagery. The magic of translation takes place in moving paint around on the canvas.

Modernism

There have always been two approaches to the histories of art: through form, the set of concerns within which artists have pursued their craft, and through content, the shared social assumptions of literature and history, that has in most centuries been of most concern to the pipers who called the artists' tunes. Modernism prised these two approaches apart. Late nineteenth century social assumptions were deeply challenged, and critics suggested that the artists' craft was enough in itself, autonomous. But content was irrepressible, and for the last thirty years or so we have been re-writing the histories of art again to stitch the two approaches

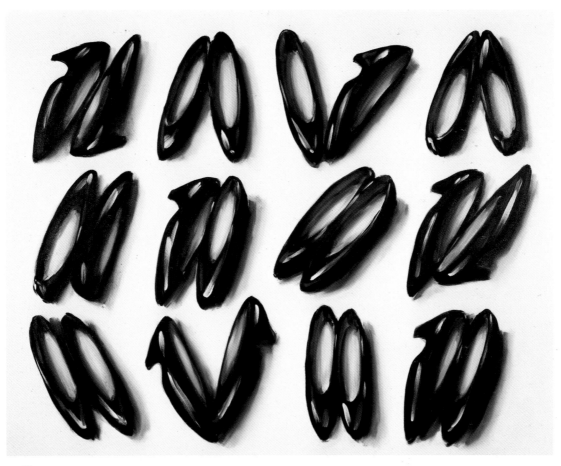

2 **Shoes** 1985

back together. But form and content will never again have quite the innocent relationship they once appeared to have in the era of the Academies.

As an artist, Lisa Milroy's relation to the history of art starts from the craft of painting, and to that extent she is a modernist, a formalist. So the use of motifs that parallel those of other artists (a still life from Manet, a dog from Velázquez, landscapes from Japanese prints, stories from comic strips) takes its motivation from the need to find ways of making paintings, not in order to share in a common culture of content. As has been pointed out in relation to her 'object paintings' of the 1980s, they are to some extent aligned to Jasper Johns' 'flag' paintings: abstract paintings using an image that is also an object in a way that both recognises and empties out its everyday meanings. The work of Gerhard Richter similarly makes play of the essentially abstract nature of painting even while we 'recognise' an image, derived from a photograph, constructed in the painting.

The place of photography in Lisa Milroy's work needs discussion, if only to be able to set it aside and move nearer to the heart of the paintings. Photographically-generated images are just one of the sources of imagery she uses, and she accords photography no special status.

But for us, looking at her work, it is hard not to be influenced by the sheer volume of images we see every day that are generated by the camera. If only because it is a label lying easily to hand, her paintings might be seen as 'photographic realism', a term that suggests everything that her paintings are not: they are neither photographic nor realism, but carefully constructed paintings of images. It is true that the camera has 'claimed' a kind of imagery, and any painter might resent the potential closure on the act of painting that this may imply. Lisa Milroy is keen to challenge or reverse the bias photography has created in the way that people look at the world. Painting, in her hands, can make even photographically-generated images unfamiliar once again and heal or restore their emotional charge.

This is the tension at the heart of Lisa Milroy's project, between her avowed intention of the formal business of translation (image into paint), and the creation of an unlooked-for surplus of emotion in the completed painting. She takes images that are often anonymous, obscure, impersonal, and invests them with the meaning of being a created, a painted thing. *Shoes* (1985) may be an exercise in the formal qualities of paint to convey texture but it is also charged with fetishism; *Melons* (1986) is distinctly libidinal. *Japanese Prints* (1989) and *Stamps* (1990) betray a sense of excitement in exoticism along with the skill of the portrayal of two-dimensional images as arrangements of objects. In a complex interior such as *Kyoto Warehouse* (1994), the variation of painted marks, the subjectively interpreted spaces and suppressed or dramatised effects of light, the material presence of colour as a layered substance, all express the investment of this unlikely and detached image with the artist's sense of value.

The paintings, unlike a photograph, have no dominant perspective, no 'privileged' viewpoint (the perspective imposed by the camera lens – for which we have no equivalent when we look at the world through our own eyes). Her paintings are disconcerting partly because there is no obvious way to read them – we each have to make up our own mind as to how to look at them, in what order we study the constituent parts. This lack of a visual 'hierarchy' has been rightly cited as an indication of their abstraction as paintings. It has also been suggested that this indicates a nihilist, alienated or anti-humanist philosophy behind them. I do not believe this is true in general, although there are certainly some paintings in her work that are 'about' alienation or detachment (*Student Geisha* (1999) for instance). In paintings that reflect the real world, we expect hierarchies of vision (points of focus, ordering of spaces, differentiation of value through paint surface). We need hierarchy of vision in order to see us safely through the day without being run over by a bus. But Lisa Milroy's paintings are not 'about' the real world and so the qualities of her paintings are not primarily about looking but about feeling. They are an imagined world, a world recreated existentially. In the world of the imagination the image is above all a network of feeling, with everything related to everything else.

One of the themes of modernism has been its reductive energy: the idea that there could be the perfect painting (black square) or the perfect building (monolith) in which less is invariably regarded as more. Against this tendency, post-modernism has been seen as eclectic, relaxed, playful, ready to embrace complexity and confusion. Many artists since Monet have worked in series, repeating the same subject in many forms, and whether one regards this tendency as an attempt to paint the perfect image (reductive modernist) or a celebration of potential and diversity (expansive post-modernist) depends largely on one's own instincts. My feeling is that

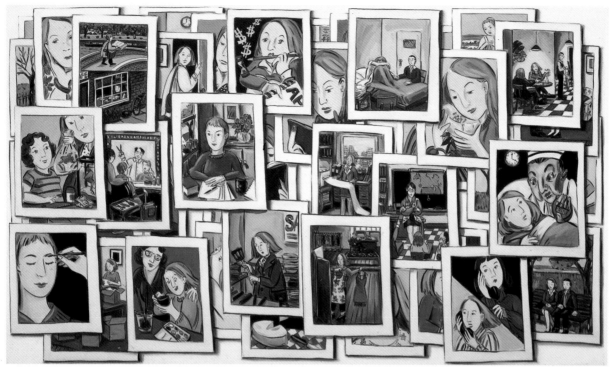

4 **Scenes from a Life** 1999

with Lisa Milroy's work, her 'lists' of objects and images within one painting (melons, records, Japanese prints, images from memory, etc.), and the 'series' of subjects across several canvases (Japanese sweets, street scenes, figures) are the latter – a celebration of diversity, a denial of the idea of perfectibility. 'Listing' is an organising principle, of course, a way of formalising material. But it is a very gentle and respectful one, allowing each item its individuality.

The gentleness and respectfulness of her vision is a curiously unfashionable characteristic when most artists have accepted the need to promote their work through assigning it a 'position' in art politics and in art marketing. It is as if she had decided that instead of opposing strength with strength, she would simply absorb and transmute with quiet subtlety whatever images she comes across. Her range of images is extraordinary, in itself evidence of her ability to take risks. Likewise, she seems able to accept the danger of constantly inventing new ways of handling paint, and to succeed in redeeming through its magic even the most unlikely imagery to a kind of glamour.

Moods

The crucial question, after exploring where and how the paintings are made, and their place in contemporary culture, is why Lisa Milroy chooses a particular image as the basis for a painting? What role does the origin of the image, its original referent, continue to play in the completed painting? Or why do certain kinds of images in her work give place to a new range of images? It is all too clear that any attempt to deal with the work as a whole, as a generality, must be seriously inadequate in the face of such variety, the various ways of painting as well as the various categories of images.

It is tempting to look for some biographical reason as to why she should have broken free from the category of 'object paintings' in the early 1990s, and expanded her range of subjects significantly in each succeeding year. In the 1990s, she undertook a number of extended travels, in Japan, in Italy, in North America and in Africa, and it might be possible to trace chronological links between certain motifs in the paintings and these trips. Again, the recent paintings of cartoon style memories were produced after a childhood friend invited her to illustrate a novel. But in the end these external biographical details have no more than a formal explanatory value, and are irrelevant to the inner life of the painting. The choice of an image is made (from the infinite number of possibilities) to create a mood. To experience the emotion locked in the paintings – loss, wonderment, humour, alienation, delight, wit, sensuality and most of all perhaps compassion – it is necessary to look at the paintings themselves.

Another way of thinking about the artists' choice of motifs for the different series is to compare these with the traditional *genres*. For example, many of the critics who wrote about Lisa Milroy's work in the 1980s compared her 'object paintings' with the *genre* of 'still life'. The travel paintings can be seen as 'landscape', the animals and people as 'portraits' and the comic strip paintings as 'history painting'. Lisa Milroy has supported this way of looking at the work by saying that she would like to integrate all the different *genres* into a single complex composition. But in the end, apart from underlining the remarkable range and ambition of her work (in terms of the varieties of art and of the varieties of human experience), a comparison with traditional *genres* is no more explanatory than biographical 'keys'. The *genre* convention, after all, referred to a shared world of objects, of moral values and of a literary, mythological or historical canon. Lisa Milroy's paintings, like any works primarily of the imagination, are too private to relate easily to those conventional shared assumptions. They refer to no precedent, have no narrative or literary support, and suggest no moral.

Look, for example, at the series of twelve *London* paintings (1999). They are painted in gloss paint on MDF, creating a hard flat surface that is surprisingly unreflective. Considerable spatial depth is created through the use of tonal perspective, tones that are nevertheless too hard to be atmospheric. The field of view seems chock-full of concrete objects. There is a simple directness in the handling of the paint, the result entirely credible because conceptually accurate (consistent with the imagination) rather than visually accurate. What are these paintings 'about'? Where does 'London' return as the content or referent of these painted images? There is a strange disjunction between the variety of 'human interest' and 'expression' portrayed and the impersonal detachment (lack of focus) of the viewpoint. We feel nevertheless that alongside the impersonality there is an intimacy, a feeling of great affection for even the bleakest scene, legible in the attention to detail, the painstaking creation of surfaces. As it

happens, these are all scenes that the artist might see on any day, habitual, fitting like old clothes, but she lavishes such painterly affection equally on images of places she has never seen. Presence and absence, vulnerable and invulnerable; the paintings remain disconcerting in their elusiveness.

In the end we can only guess at why the artist has chosen a particular motif, particularly as it is likely that the artist is herself only partially aware. In any case, it would be a crude misunderstanding of the creative process to think that any artist should herself be 'in' a particular frame of mind while making a painting in order for that frame of mind to be encoded in the painting. What is important is what we find in the images (and each of us will find something different), not whether whatever it is that we experience corresponds with the artist's conscious and whole intention.

I used the word 'mood' to title this section because it describes best what the paintings mean to me, their emotional potential. The dominance of the novel and the film has made us highly sensitised to respond to the artistic strategies of narrative and characterisation. These are absent from Lisa Milroy's paintings (and their absence, of course, is disconcerting to us). What we have instead is abundant atmosphere, emotion, qualities that are found in the film still or the single page of a novel – in other words in a static moment – rather than through unfolding time. Paradoxically, this makes it more important to spend time looking at the paintings. Despite their apparent lucidity, they reward contemplation, do not reveal themselves in a moment. It is an exciting challenge, to open ourselves to the force and variety of the moods in the different paintings. The reward is to allow ourselves to feel alienation before one painting and the surprise of revealed sensuality when we look at the next.

It is sometimes useful to explore an artist's falterings along with her successes. Lisa Milroy admits to an ambition that has so far eluded her. She would like to paint an image that functioned only or 'merely' as an object in the world, wholly indifferent to the subjectivity of the artist or the viewer. Her paintings of Japanese paper, for instance, are convincing if perhaps modest examples of this. But almost all her subjects already contain within them the visible traces of humanity, and often it is these that encode the emotional resonance of the painting alongside the way in which the painted image has been constructed with the brush. Her great challenge is to paint 'nature' without the cultural attributes which inevitably seem to attach to it as soon as it is the subject of an image (Ruskin's 'pathetic fallacy'). Deep in her North American being, she knows that 'nature' has no need of humanity. One of her most successful paintings is a huge skyscape, *Sky* (1997–98), truly intimidating in its vertiginous lack of human scale, and yet even in this painting it is impossible to escape the sense of the acculturation of nature that takes place as soon as an image is made.

Why avoid culture? The ability to use any, absolutely any, image as the seed for the creation of a new object in the world is a scary and dangerous talent. It must be tempting to hide from it, to wish that some images were invulnerable to the painter's passion, too boring to excite the painter's eye. For the meanwhile, the relationship Lisa Milroy has with her images – she redeems them by recalling them into emotion – continues to prompt her for the most part to select images of artifice, that bear the traces of human desire.

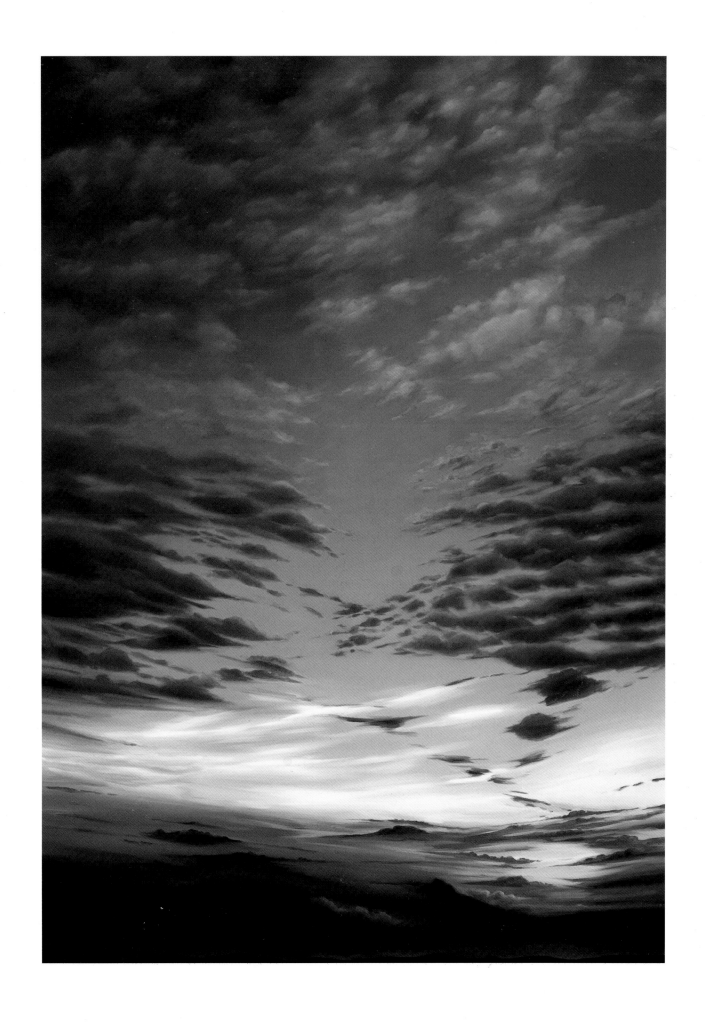

5 **Sky** 1997–98

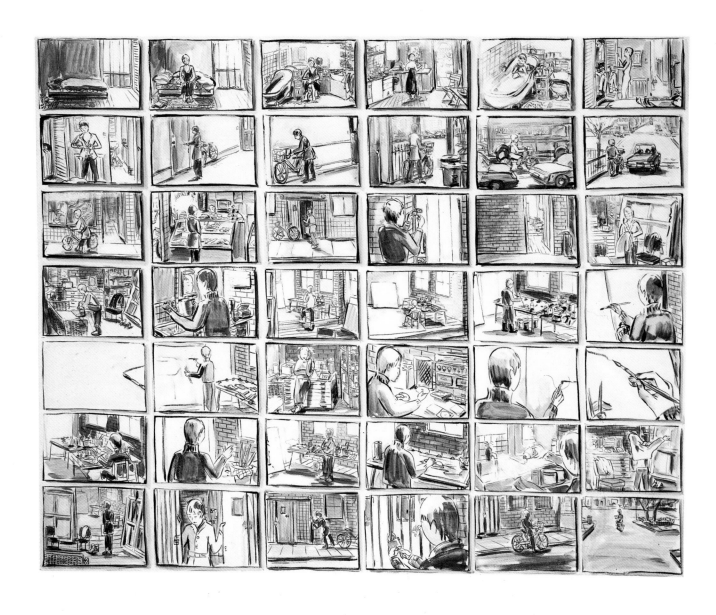

Lisa Milroy's Painting
Fiona Bradley

Paintings have multiple existences. Moving from their creator's mind into the studio and then the gallery, they have another life once reproduced in images and words in an exhibition catalogue. Imagined, executed and described, they operate as dual signs, linking chains of association along the twin axes of the visual and the verbal, their potential meaning sliding continuously between the two. Lisa Milroy accepts that painting is inextricably bound up with the business of language as it is expressed in both speaking and writing. As a painter, however, she is nevertheless primarily interested in that part of painting which escapes this inevitability – in the core of the activity in the studio which words can't quite contain. She describes what her paintings do as 'giving space to looking'. If, as has been long suggested, first in literary theory and then in Minimalism and Conceptual art, it may be true that rather than organising language our thoughts are in fact organised by it, then the language that Milroy subjects herself and the viewer to is that of paint.

On the evidence of her paintings, this is a conceptual rather than a romantic or expressionistic impulse. Although revelling in the sensual and descriptive power of paint, Milroy's obvious enjoyment of the brushstroke as a material intuition, aside from thought as expressed or directed by language, is linked to an understanding of its art historical and cultural lineage. The brushstroke is as likely to describe itself and the canvas it covers as it is to engage with objects or emotions external to it. Milroy's paintings highlight the primacy of the brushstroke, playing deliberately with surface rather than depth, and if they encourage escapism on the part of the viewer or the painter, it is an escape into the space of the picture plane rather than through it to some mythical 'beyond'.

Two paintings from 1988, *Light Bulbs* and *Pulleys, Handles, Castors, Locks and Hinges* bring together assortments of related objects you could hold in your hand. Their arrangement is not unprecedented in the real world – the orderly rows of light bulbs and ironmongery have their counterparts in the pages of catalogues, in shop window displays and even in the hall cupboard at home after a bout of obsessive tidying – but it ties the objects to the picture plane in a way that has little to do with them, and everything to do with the paint that describes them. They are resolutely painted objects.

Rejecting the illusionism of photo-realism, Milroy's objects are not perfect replicas of those in the real world. They have bits missing, having been edited once in her memory and again by her brush. The wheels of the castors have been glossed by paint, the translucent light bulbs have a painterly materiality. The paintings seem uninvolved with mimesis, not interested in mimicking either the reality of objects in three dimensions, or any pre-existing representations of them in two. They are neither originated by their relationship to reality, nor disoriginated by their relationship to represented reality. They are, purely representations, and revel in their identity as such. They exist within and for the painting, enjoying an intimate relationship with the white ground on which and at the same time as which they were painted. Completed in a single day, worked wet on wet, each is a single idea, a complete painting. They are recognisably

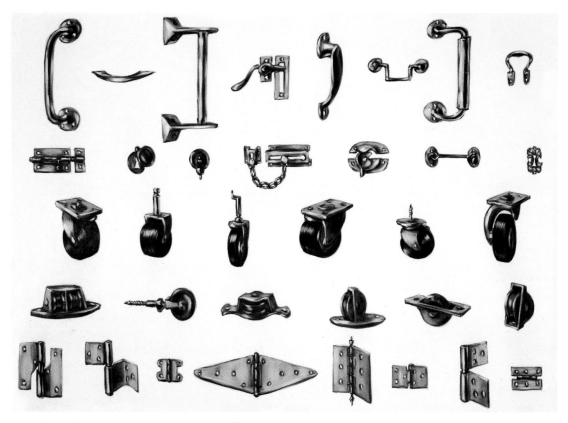

7 **Pulleys, Handles, Castors, Locks and Hinges** 1988

part of the same body of work, but have different emphases: *Pulleys, Handles, Castors, Locks and Hinges* floats its objects over its ground, playing a tidy, staccato rhythm across its surface, *Light Bulbs*, on the other hand, uses shadows (a neat trick, to paint light sources which cast shadows not light), not, as we might expect, to raise the objects off the ground into their own tangible space, but further to embed them into the ground, to nestle them down in the paint.

Milroy's representations do, of course, have a relationship to objects, but objects as they exist in the mind and memory rather than reality. Her paintings engage with what we know of objects – in what it takes to make an object stick in the mind. The objects in them are not symbolic, not chosen for an established art historical significance. Neither are they fetishistic, loaded with displaced anxiety or anger. Instead, they are chosen for the particular imaginative relationship they form with the world outside the painting, and for the possibilities they offer for communicating this. They signal outside themselves through the operation of association and possibly metonym, bringing back to mind as we look at them complete experiences, ideas or emotions. They are objects upon which minds may become snagged, perhaps because, recognising the capacity of everyday objects to operate in different ways for different people, Milroy empties them as she paints. Neutrally presented, while they are certainly highly charged, they seem just to escape being loaded.

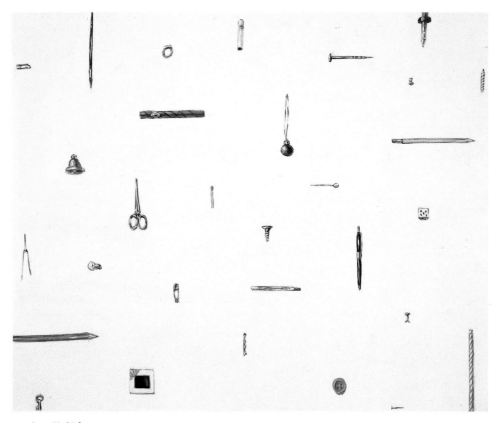

8 **Small Objects** 1987

The kind of relationship to objects enacted in Milroy's paintings may be glimpsed in the artist's fascination with the way books work. Her paintings of books present them simply, as generic objects, classic library books – hardbacks, with matt covers in simple reds, blues and greens. Like real books, they guard their secrets from the casual observer. Milroy is acutely aware of books as tangible objects connected to the world by the conventions of their appearance and the physical act of handling that reading entails. At the same time, she knows that this is not entirely where their meaning lies: a book's identity is conferred on it more by the parallel reality evoked in the words on its pages than by its material existence as an object in the world. When we think of a book we like, we may recall its size, the space it occupies on our shelf or the image on its cover, but all this is only really an empty container back into which we can project what the book is actually about.

Emptied objects – emptied only so that they may immediately be filled with personalised meaning – are potential love objects. Or lost objects: those things which, once lost, we invest with disproportionate importance. Milroy's objects are both loved and lost. Looking at them, we experience a rush of recognition and pleasure. And also wonder – they are not how we remember them at all.

9 **Squares** 1991

Shoes (1985) achieves its immediate impact through repetition. Twelve pairs of generic black court shoes are arranged in three rows over the painting's surface. Literally empty, they are also completely bland, their only gorgeousness that of the painted light modelling their shiny surface. Variations on a theme, they represent every pair of shoes we may ever have loved, neglected or lost. Their careful emptiness also allows them to signal off at wild tangents – why do they remind us of mussel shells when our actual shoes never do? *Small Objects* (1987) is a group of those kinds of objects which quickly become first indispensable then elusive. How much time do we spend looking for the particular pen which is the only one we can possibly use to write with today; the wishbone we saved from a special dinner; the cufflink we must find before we can even begin to think about getting ready to go out? Arranged meticulously across the picture plane as though on a tray prepared for a childhood memory game, the small objects lie in wait for us, ready for us to bring them back to life and into memory with anecdote and association.

A group of paintings from the early 1990s operates much less directly, and brings something rather more nebulous to mind. In fact, something abstract: they came about when Milroy, searching for a new language for painting through which to think about the world, turned her attention to abstract nouns. The resulting paintings are about objects (nouns are 'naming words', they name objects) like 'circulation', 'constellation' and 'traffic'. Their common element, the thing which characterises them in memory and which must be reproduced in painting if they are to be meaningful for the viewer, is distribution rather than appearance.

If abstract paintings such as *Squares* (1991), a regular, gridded arrangement of squares sorted into randomly-distributed blocks of colour, objectify the linguistic convention of the abstract noun, Milroy's 'travel paintings' do similar things with our collusion in the travel industry's marketing of place. Exotic locations exist only briefly in the present: first a fantasy projected on the mind from the pages of a guide book, they move swiftly into memory, their vividness rekindled in photographs. Milroy's earliest Japanese paintings use formal strategies familiar from her object paintings to engage the mind of the viewer. *Aquariums* (1993) stacks a grid of nine fish tanks into a small space, while *Hair Dye* (1993), captures a minuscule proportion of an obviously impressive foreign shop display. As in the object paintings whose visual structure these works share, the repetition of the painted elements both fends us off and draws us in. Their insistent reduplication of each other makes a barrier of them, excluding us. We are external to them, foreign to them. Yet their exoticism intrigues and, as we bring our curiosity to the regularity of their presentation, in some way we may come to know them intimately.

The repetition of these objects is a found repetition, naturally occurring and reproduced in the painting as a way to unite reality and the picture plane. The picture plane is completely full, the objects push right up against it. In other Japanese paintings the plane is full not of things but of space – perhaps space instead of place has become the object of the paintings. *Room* (1997) lines up a series of surfaces, parallel and at right angles to the canvas, and describes them. The room is full of articulated space – the sliding planes of the cupboards, the horizontals of the shelves, the flatness of the tatami mats on the floor. Every inch of the painting is full of noted detail, very particularly Japanese detail, and yet this is still a painting of an empty room. Empty in fact, and empty in aspiration: we are free to fill it with our own idea of what a Japanese room could be.

10 **Kyoto House** 1994 11 **Kyoto House** 1994

In *Kyoto Warehouse* (1994), as in *Room*, Milroy matches the outer parameters of the space the painting contains to the dimensions of its frame. Looking at the painting, we see the entire space of the warehouse. The painting comprehends it all: the container and the things contained. Between the materiality of the painting and the conceptual impact of its subject there is an absolute fit.

The boxes of *Kyoto Warehouse* and the spatial planes of *Room* share more than an orderly sense of placement with both Milroy's earlier and most recent work. Before they are about space, place, objects or their distribution, these paintings are about paint. Although the viewer may find meaningful associations in the content of the paintings, may find their mind becoming snagged up on the things depicted, Milroy herself does not dwell on them unduly. She has referred to the objects in her paintings as a kind of litmus paper to detect the presence of that in which she is really interested, and warns of the dangers of over-investing in subject matter.

What may interest Milroy more than anything else is the activity of painting itself. She speaks of painting – making marks with a brush on a canvas and trying to get them to mean something – in relation to habit, with all that the word implies of the demonstrable benefits of familiarity, loving and cherishing on the one hand, and the potential dangers of over-familiarity, deadening and destroying on the other. The activity of painting creates a holding pattern, enabling her to think, giving her primary material through which to organise and communicate her thoughts. And her vision: the things Milroy sees, and chooses to paint, are conditioned by how she paints rather than the other way round.

Finsbury Square (1995) combines the representational devices of the small, snapshot-like Tokyo paintings and the larger, space-based works. It shows a section of an office block in passing – the whole of the painting opens onto the building, but we still don't quite see all of it. The regular windows and rigid symmetry of the door frame tie the building firmly to the canvas, the rhythm they set up contributing to the impression that we are moving past the office rather than simply looking at it. There is an inexplicable sense of rightness to the picture: this really is Finsbury Square. It is not that the painting looks like the building but, once we have seen the painting and returned to the square, the building begins uncannily to look like the painting.

A very recent work, *A Day in the Studio* (2000), is actually about painting. In small scenes which, reminiscent of comic strip narrative convention, are both paintings-within-paintings and references back to Milroy's orderly gridded representations of the 1980s, the artist shows herself involved in the details of life in the studio. She arrives, she mixes paint, she paints, she cleans up, she wonders, she paints more, she leaves.

One of the most recent works in this exhibition, *Doing Thinking Speaking* (2000), is similarly, if less overtly, tied up with the business of painting. A representation of a crowd of people doing things on the street, with speech and thought bubbles emerging from their heads, at first glance looks unfinished. Only one part of the painting is 'properly' worked up, and all of the bubbles are empty. Yet it is finished, and the rhythms which play across its surface are tightly controlled. The sweep of luscious paint in the 'finished' section moves into and on top of the contrasting area of matt, sketched-in outline, advancing and receding with illusionistic depth. This depth is matched by the sumptuous painterliness of the empty blue thought bubbles, which at the same time rest on the surface of the painting as quantities of paint. As we investigate the painting closely, enjoying its narrative anecdote, all the present participles of its title begin to refer back to the act of painting – as an activity to be pursued, a mode of thought and a method of speech. The unfinished appearance of the painting adds a past and a hypothetical future to its insistent presents, and it comes to be about the real world and the possibilities for engagement with it as a painter – the use of the habit of painting to explore its potential for simultaneous revelation and communication.

The all-over structure and repetition of elements that both are and are not the same in *Doing Thinking Speaking* is reminiscent of the object paintings of the 1980s and, like all of Milroy's work, the painting represents a unity of concept, vision and action. The impact Milroy's paintings have on the eye is intimately bound up with her love of painting and her understanding of the world as she sees it in terms of the marks she makes to describe it. Her explanations of why she paints the things she does pivot around the kinds of brushstrokes she wants to use: the multiple hats in *Sailors' Caps* (1985) are there because she wanted to repeat the certain painted gesture she knew painting them would require; the *Crowd* paintings of 1992 are the result of wanting to see if every individual mark could be made to look like a complete person; the recent *This Painting Is Based On A Canadian Calendar, But I Was Also Thinking Of My Friend David's Farm* (1999) is an exercise in the deliberate use of paint to undermine the bland innocence of represented beauty. Representation, in the work of Lisa Milroy, is not translation. Painting is not an attempt to reproduce on the canvas what is seen in the world. It is much more about the communication of what exists in the mind. And Milroy seems to think in the language of paint.

Paintings

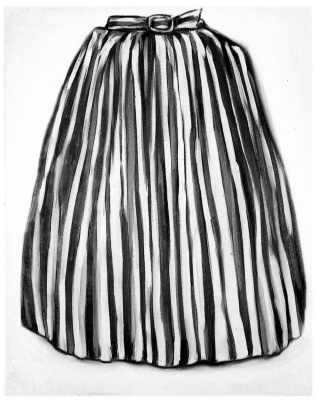

12 **Skirt** 1984

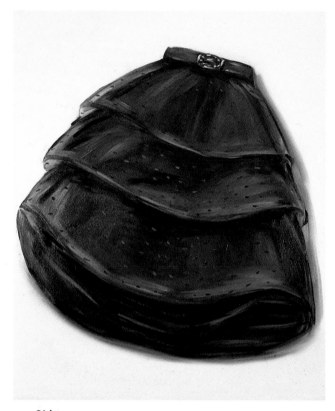

13 **Skirt** 1984

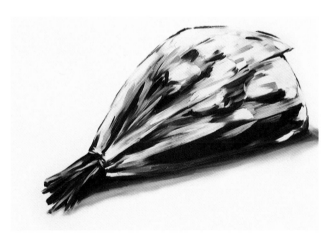

14 **Flowers** 1984

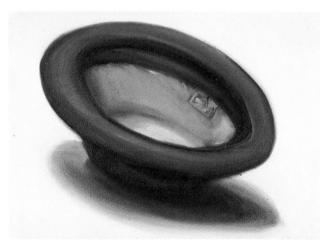

15 **Trilby** 1983

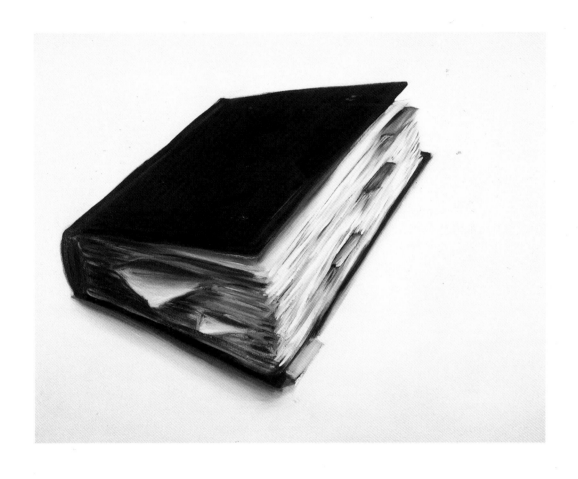

16 **Book** 1983

17 **Pyjamas** 1984

18 **Road Map** 1983

19 **Books** 1984

20 **Pile of Clothes** 1983

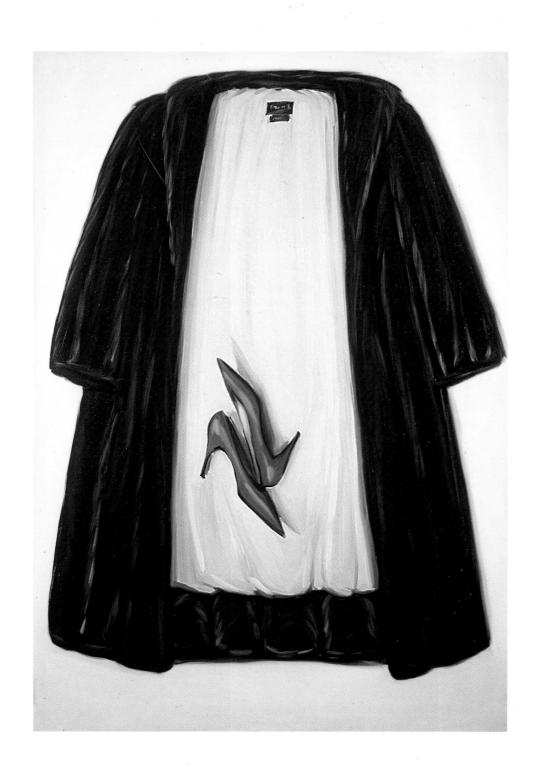

21 **Fur Coat and Shoes** 1984

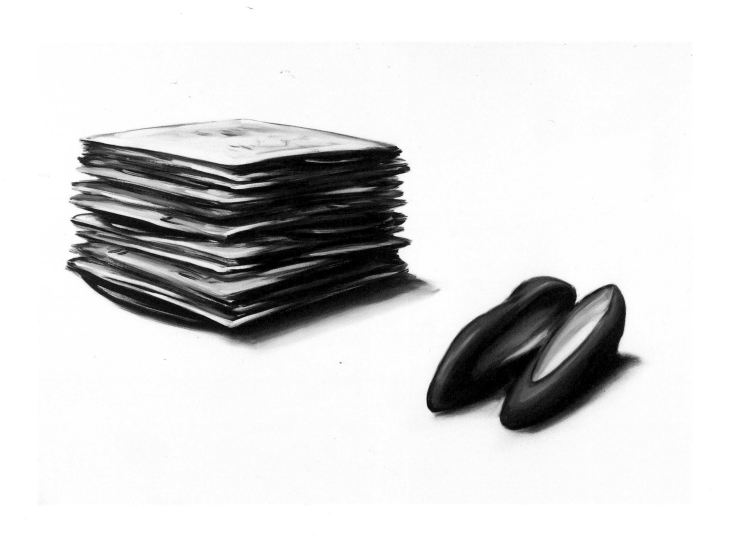

22 **Records and Shoes** 1984

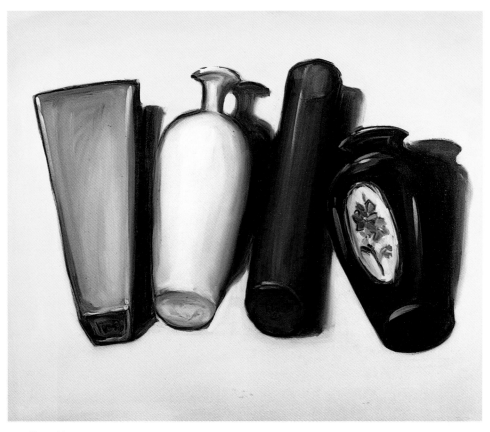

23 **Four Vases** 1984

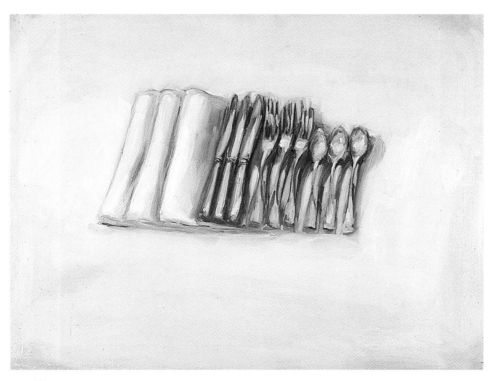

24 **Silverware** 1984

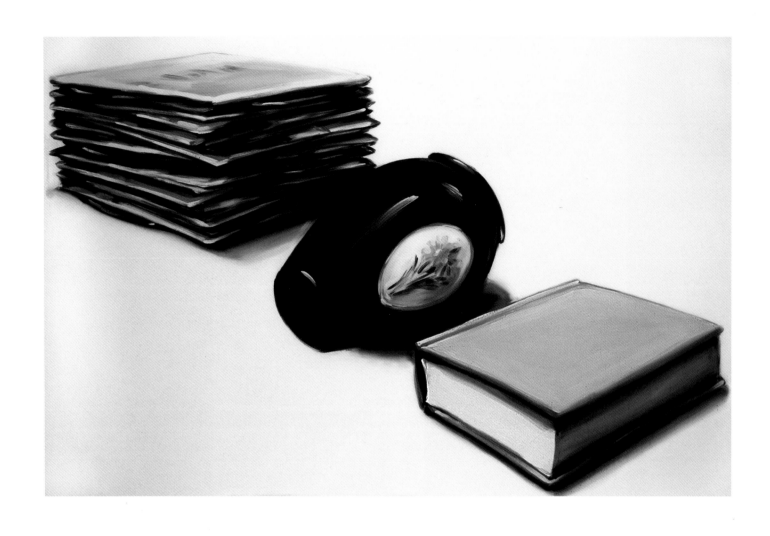

25 **Records, Vase and Book** 1985

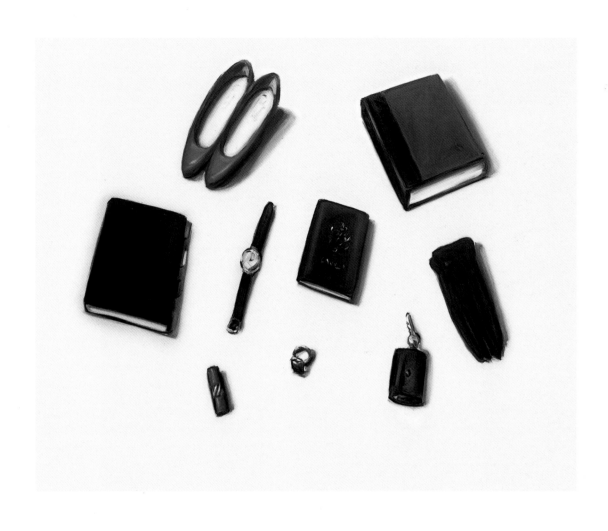

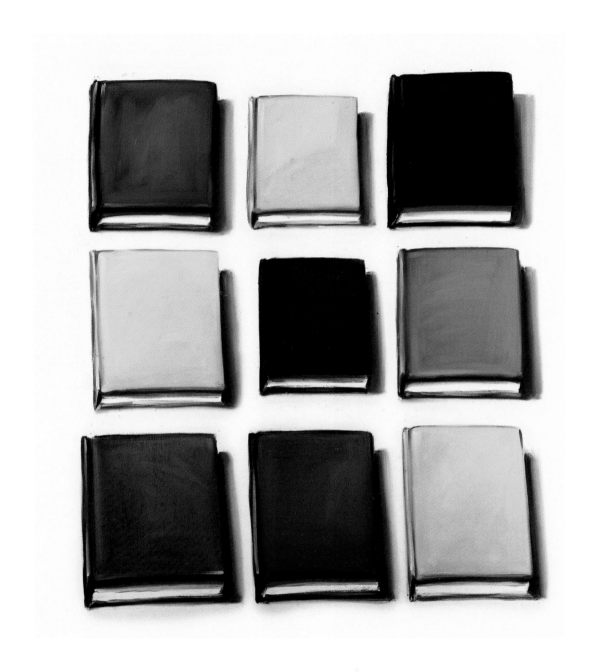

27 **Nine Books** 1984

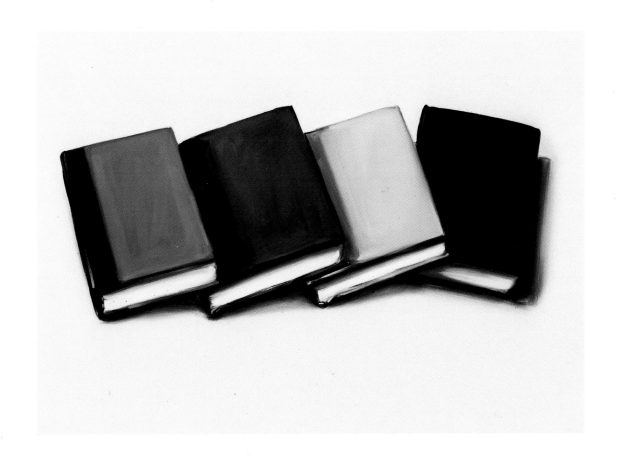

28 **Four Books** 1984

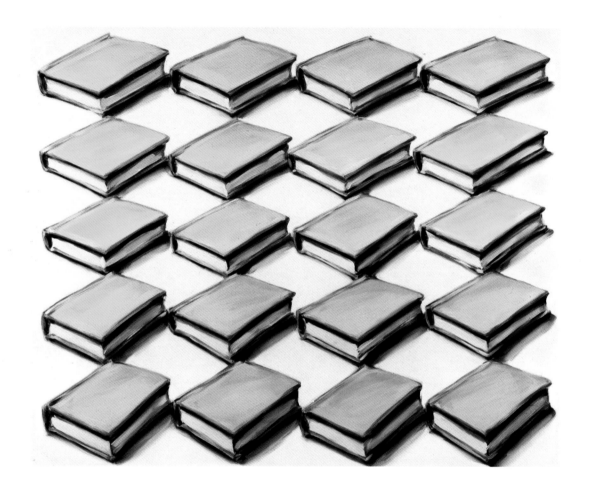

29 **Books** 1986

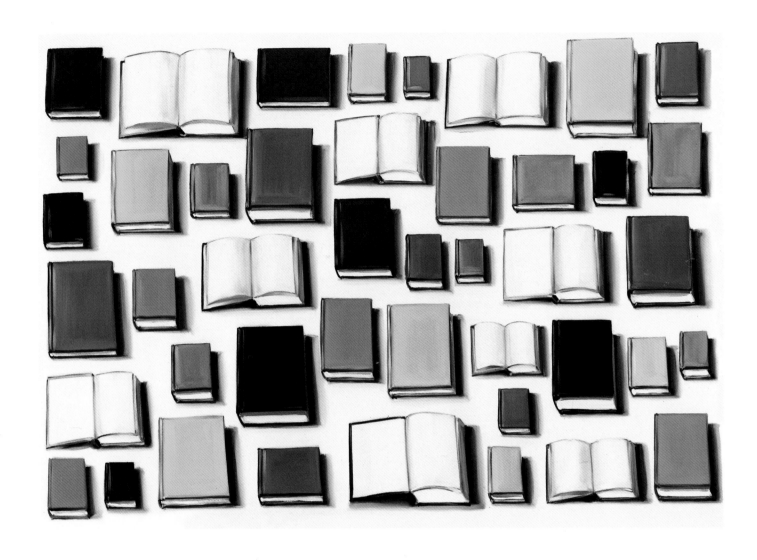

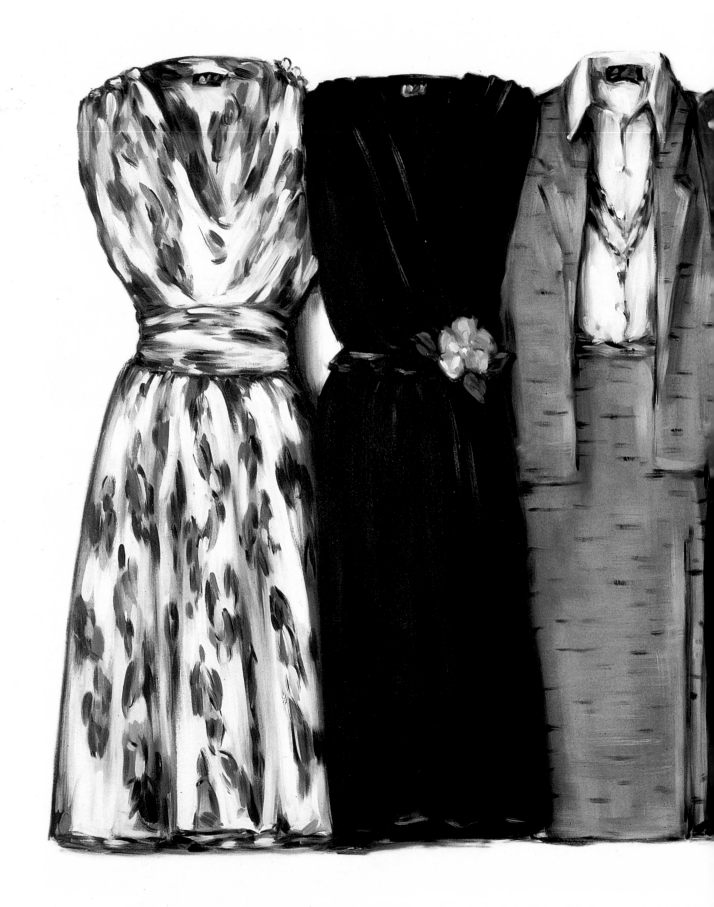

31 **Dresses** 1985

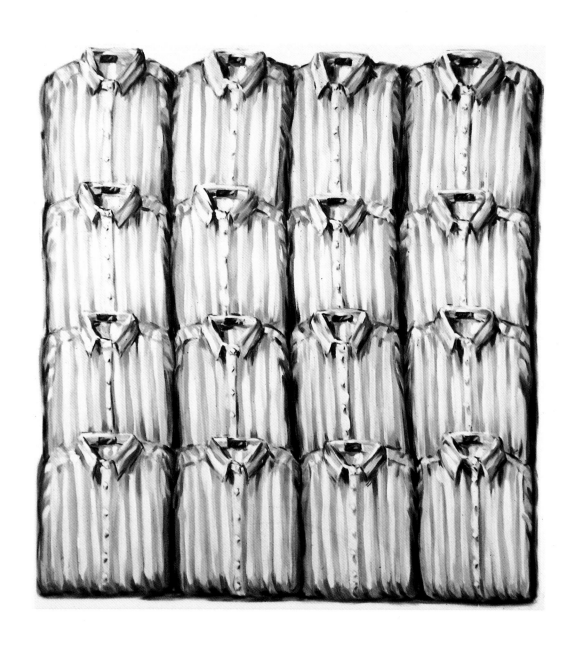

32 **Shirts** 1986

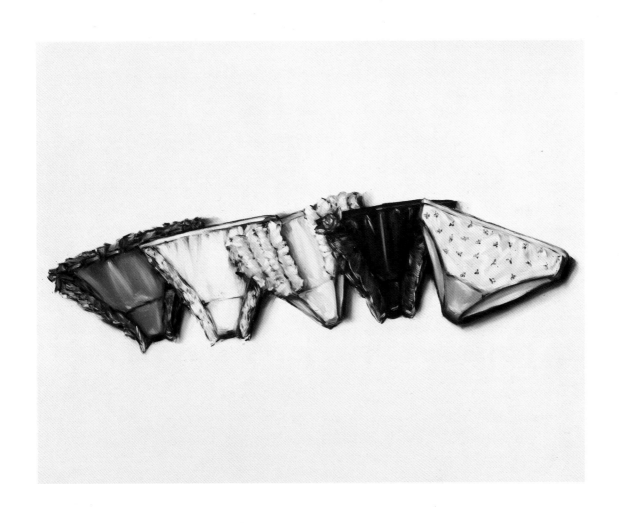

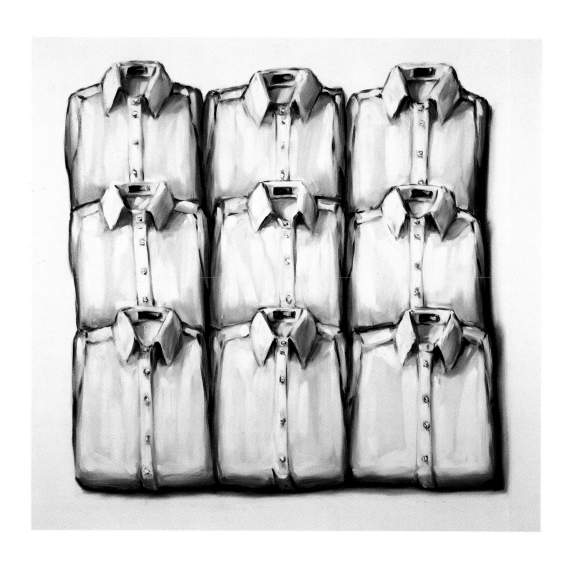

34 **Regiment** 1985

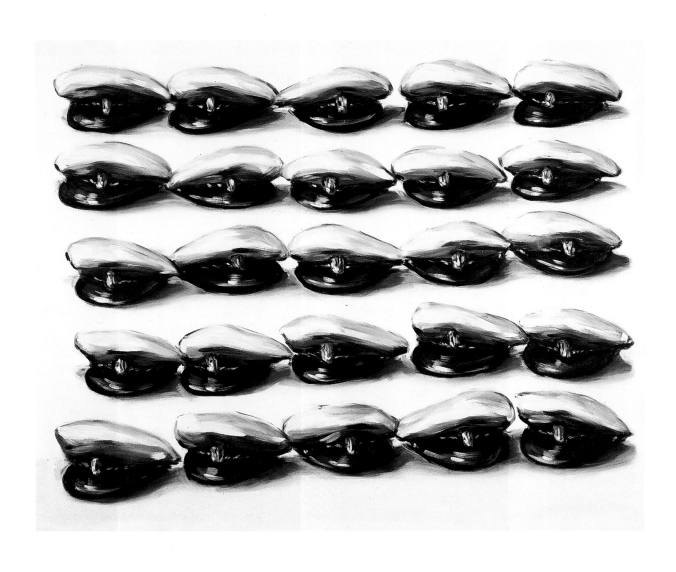

35 **Sailors' Caps** 1985

36 **Shoes** 1985

38 **Shoes** 1990

39 **Shoes** 1990

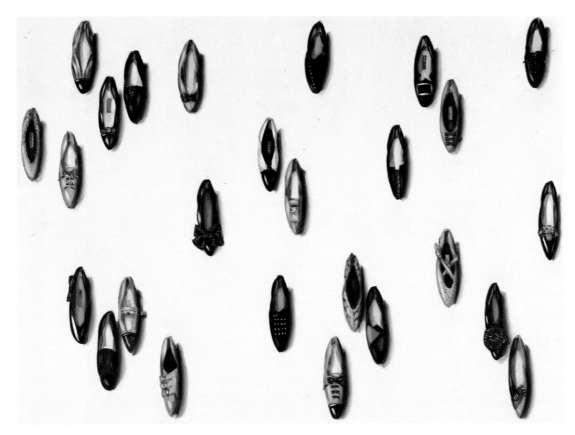

40 **Shoes** 1989

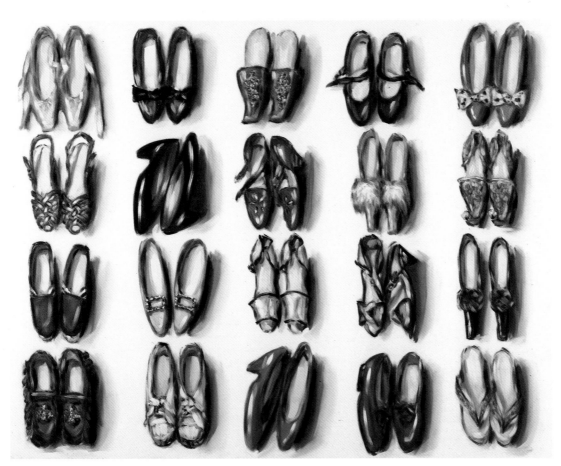

41 **Shoes** 1987

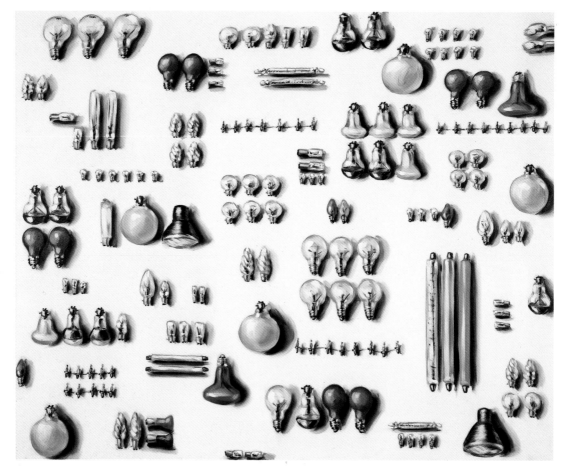

42 **Light Bulbs** 1988

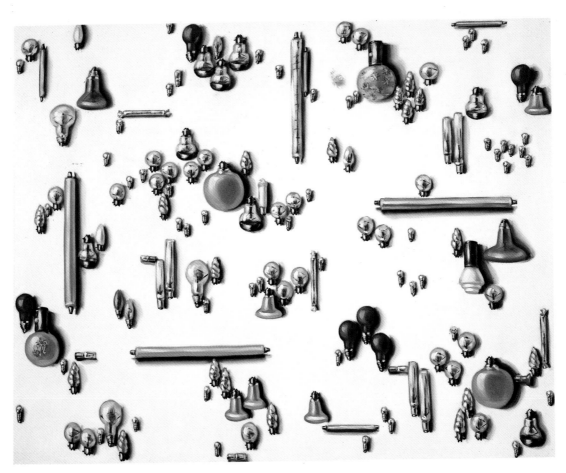

43 **Light Bulbs** 1989

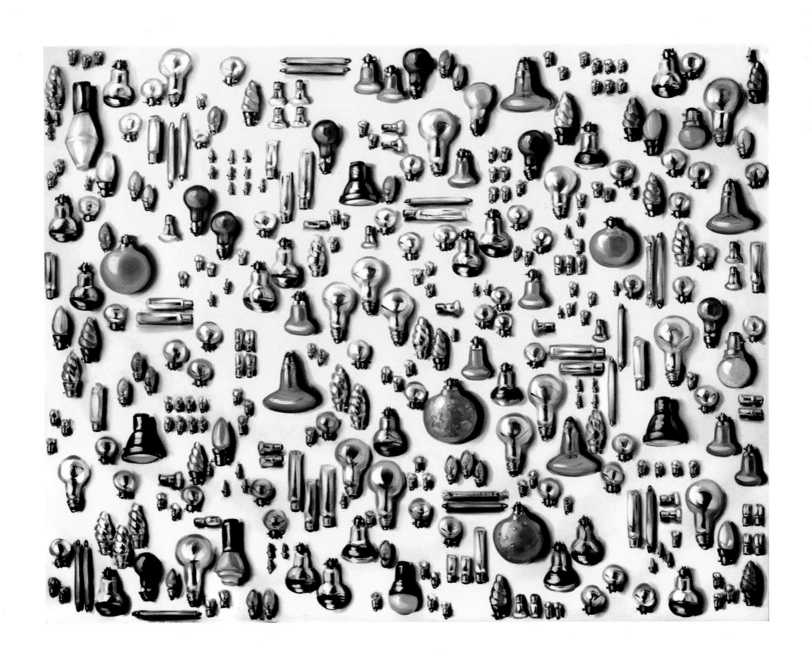

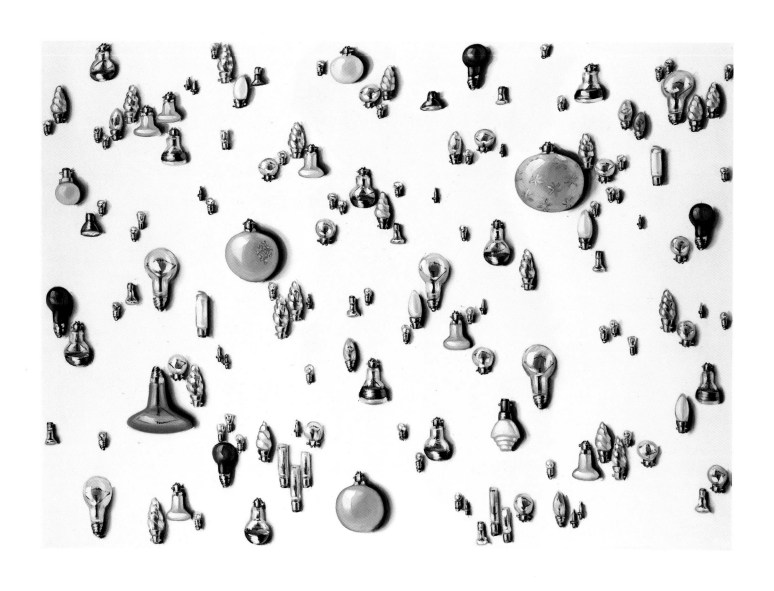

45 **Light Bulbs** 1988

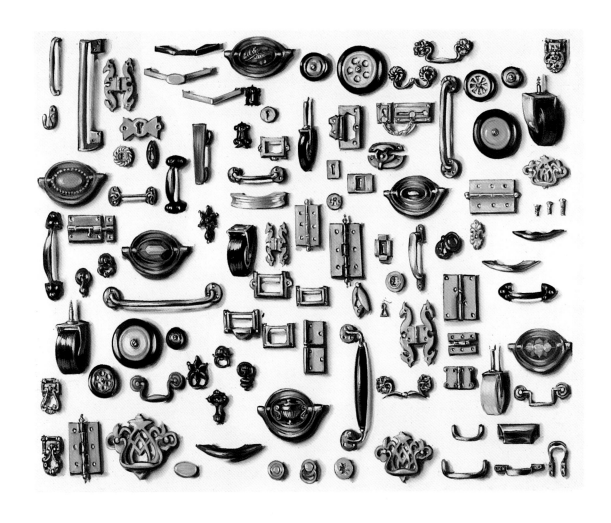

47 **Handles** 1988

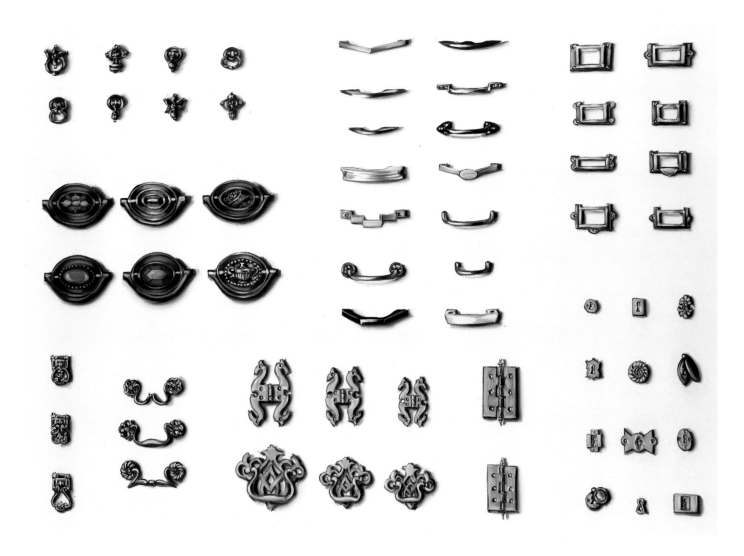

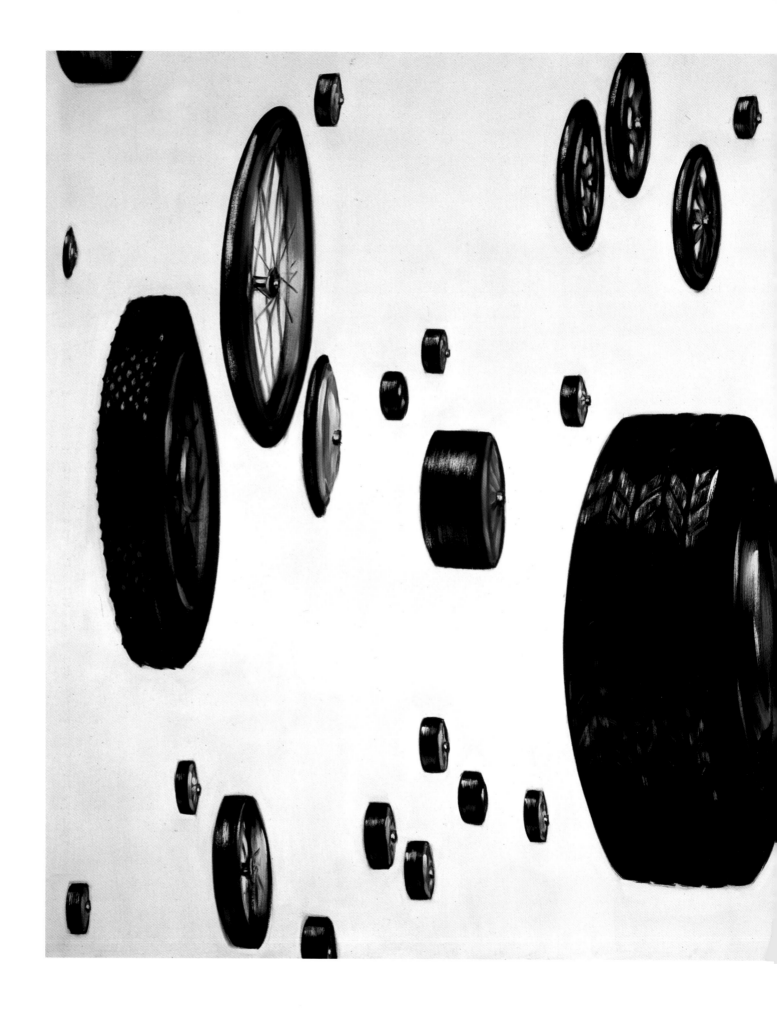

49 **Tyres** 1988

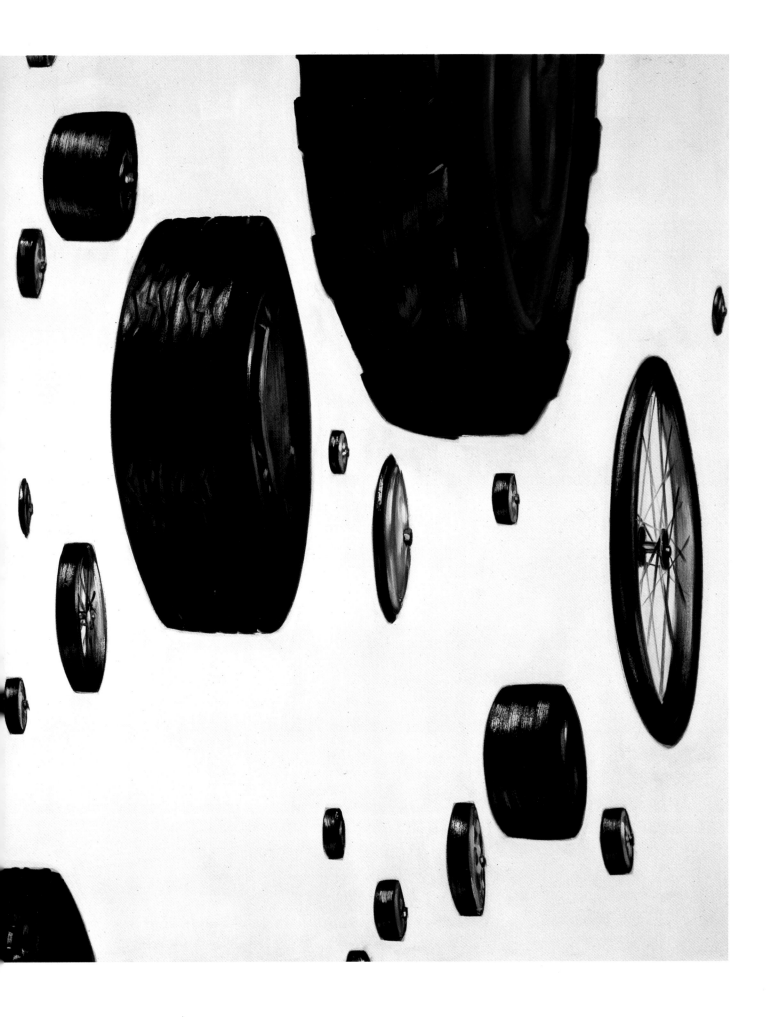

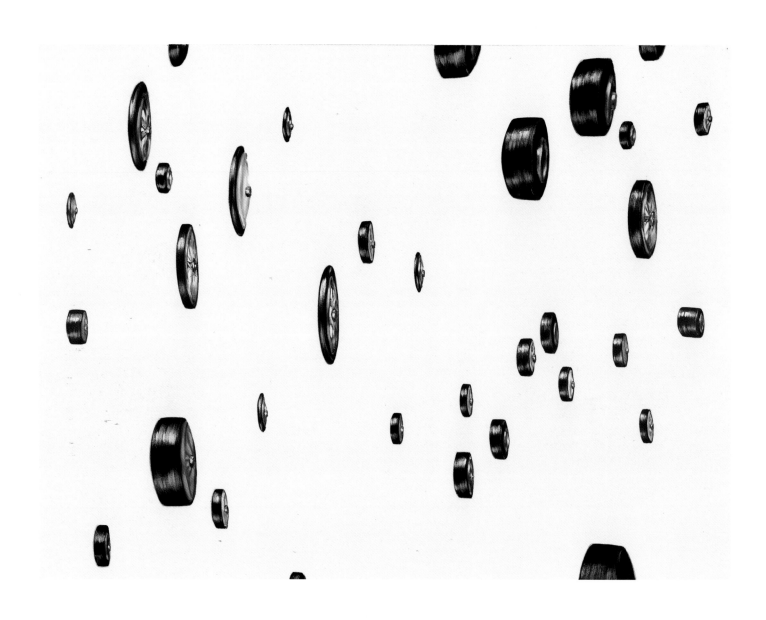

50 **Tyres** 1988

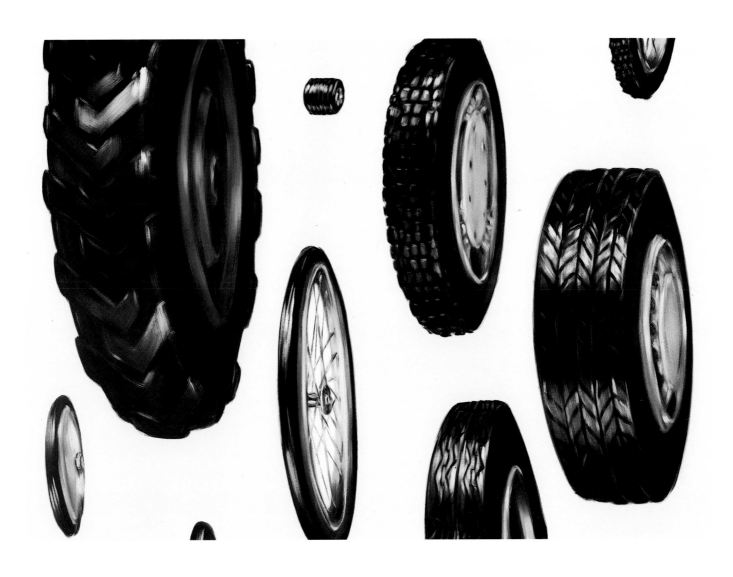

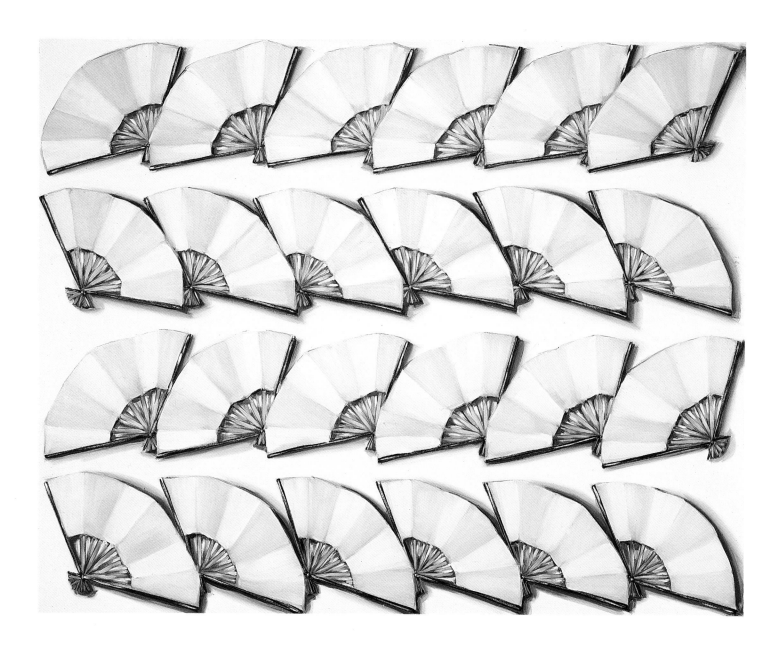

52 **Fans** 1990

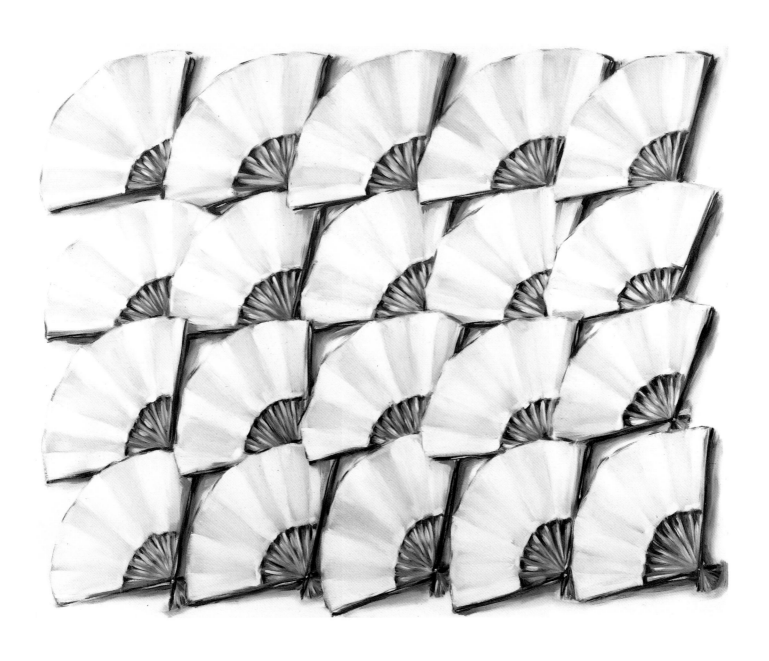

53 **Fans** 1986

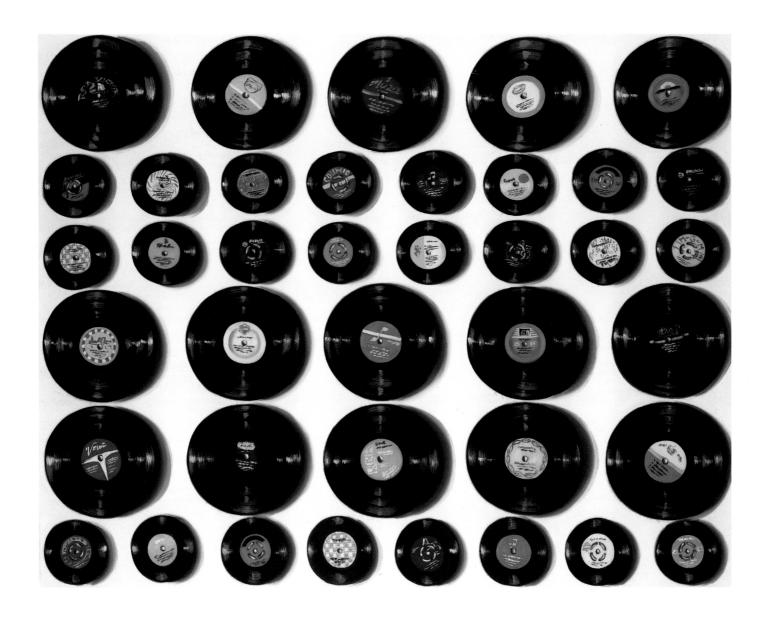

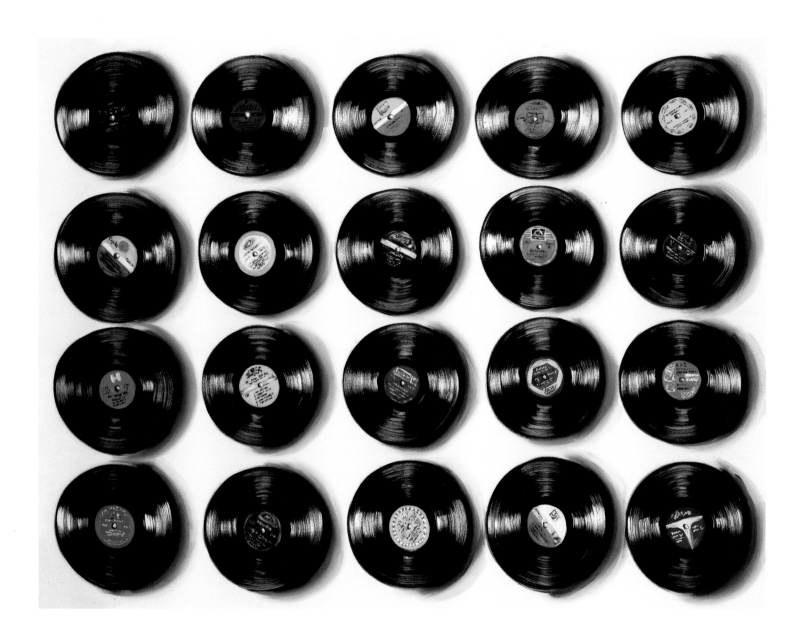

56 **Roman Coins** 1985

58 **Stamps** 1988

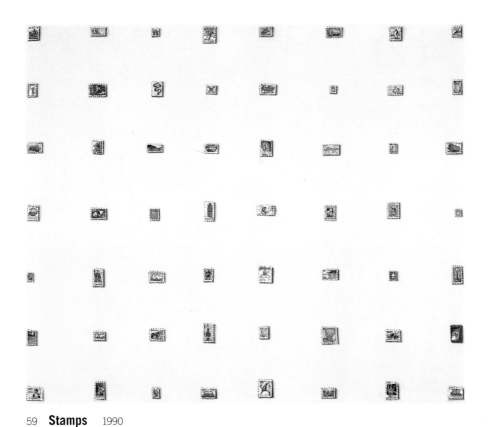

59 **Stamps** 1990

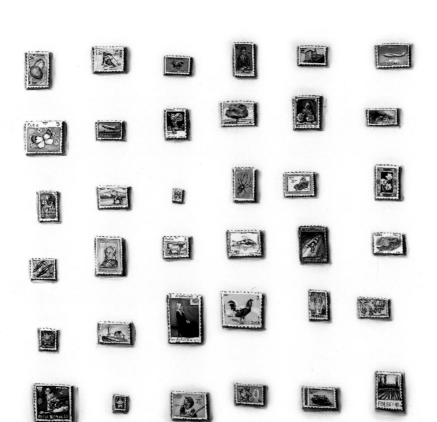

60 **Stamps** 1986

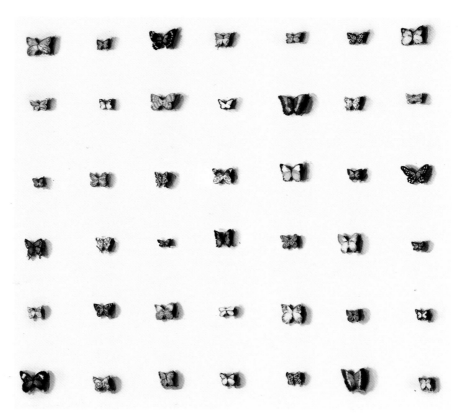

61 **Butterflies** 1988

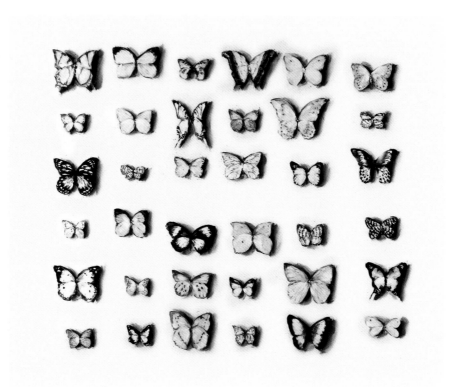

62 **Butterflies** 1986

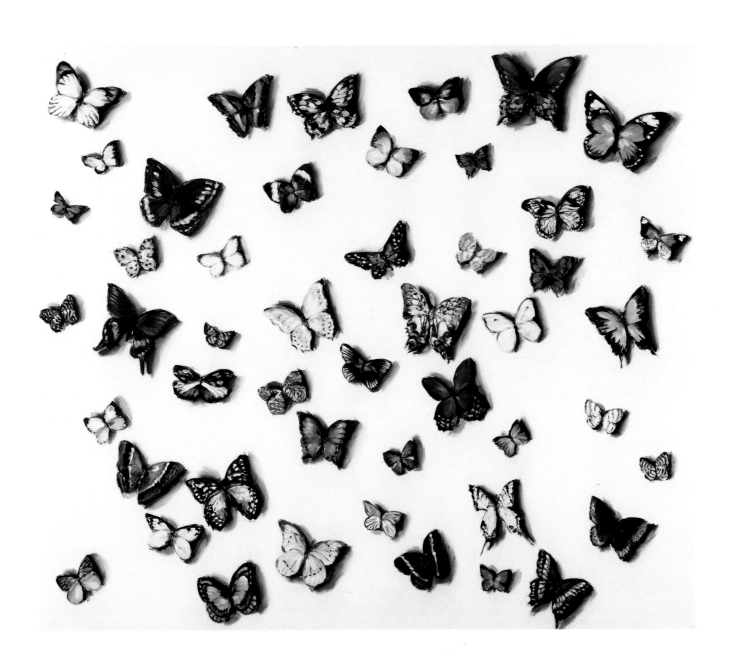

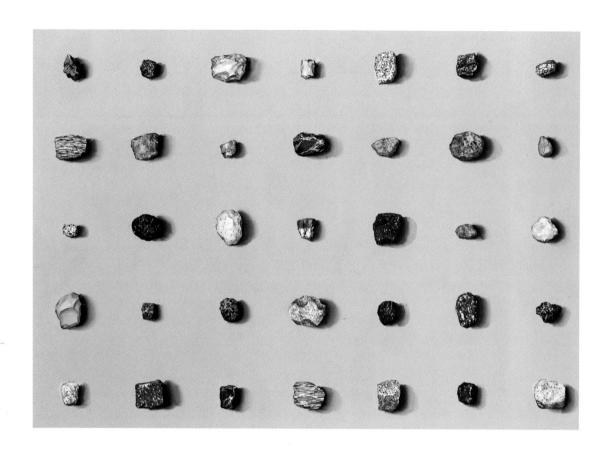

　　　64 **Rocks** 1993

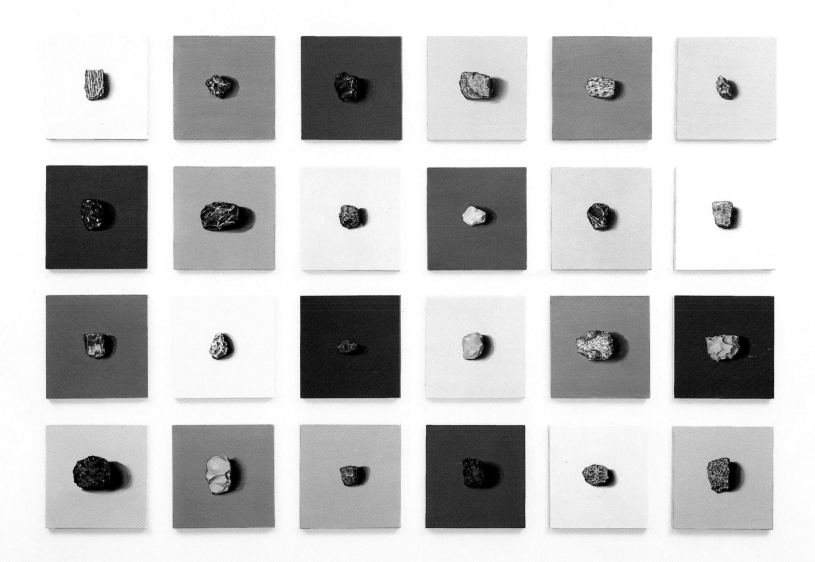

65 **Rocks** 1992

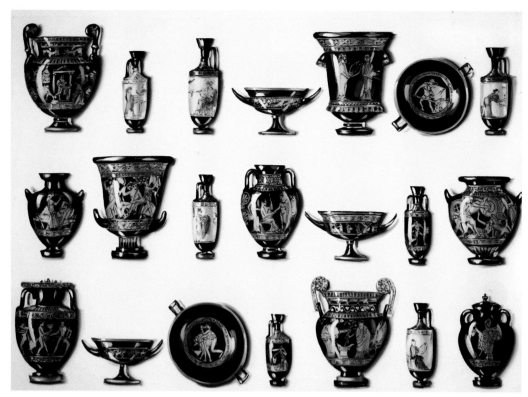

66 **Greek Vases** 1990

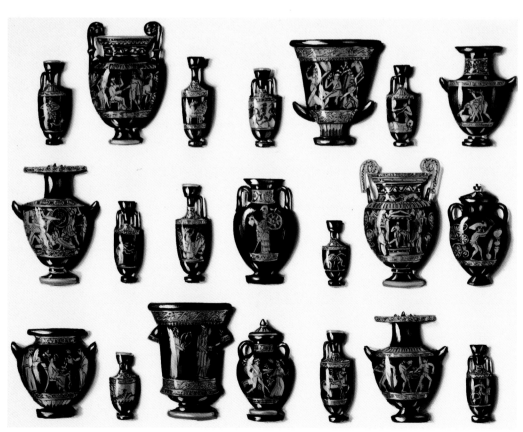

67 **Greek Vases** 1990

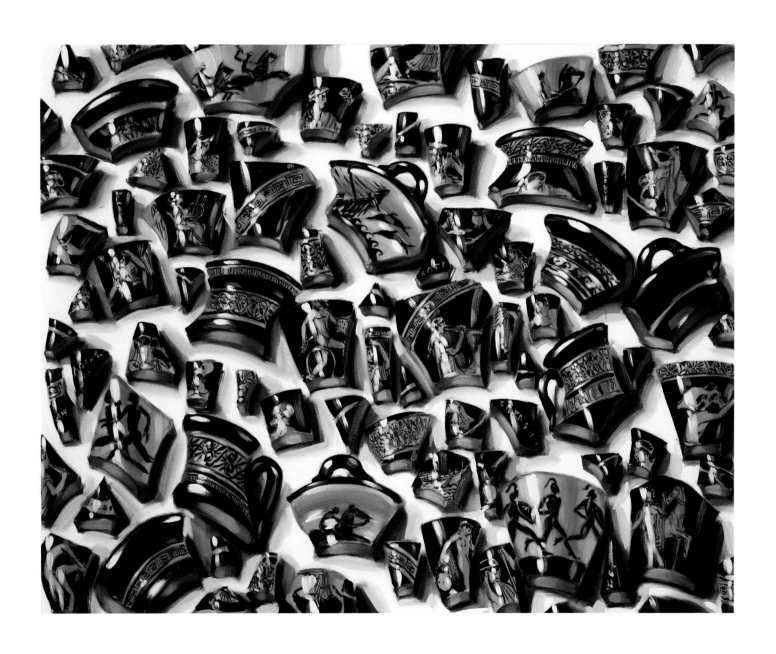

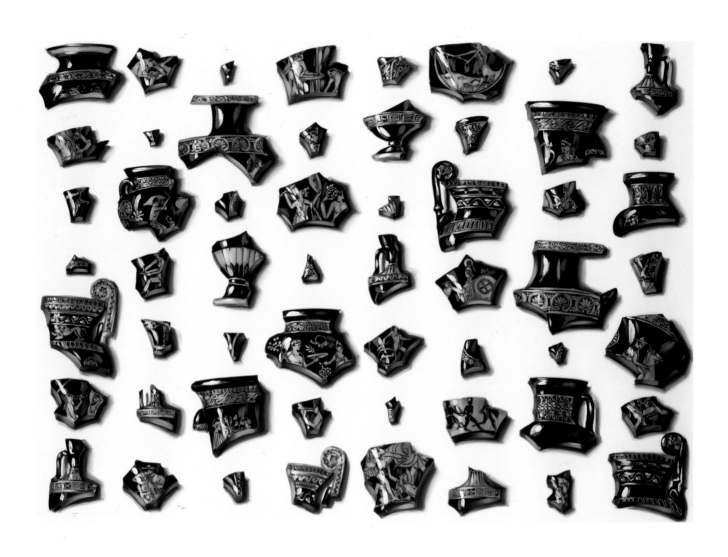

69 **Fragments** 1989

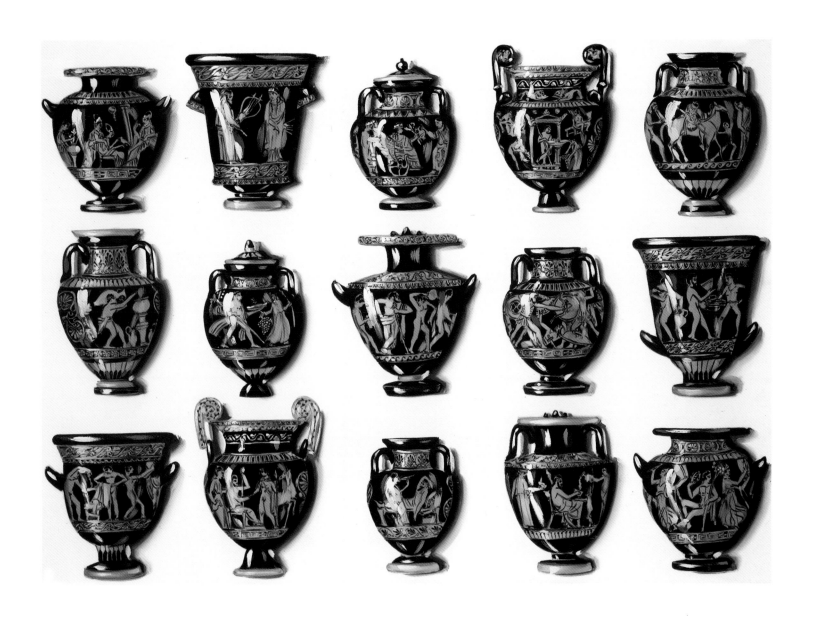

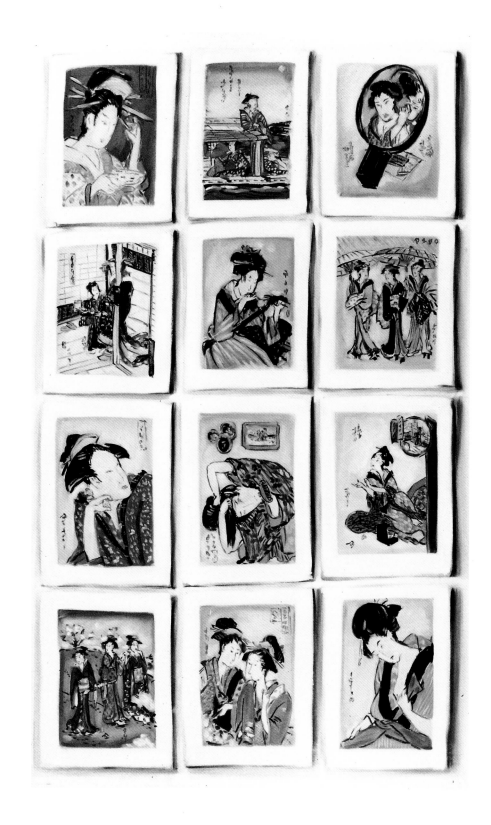

71 **Japanese Prints** 1986

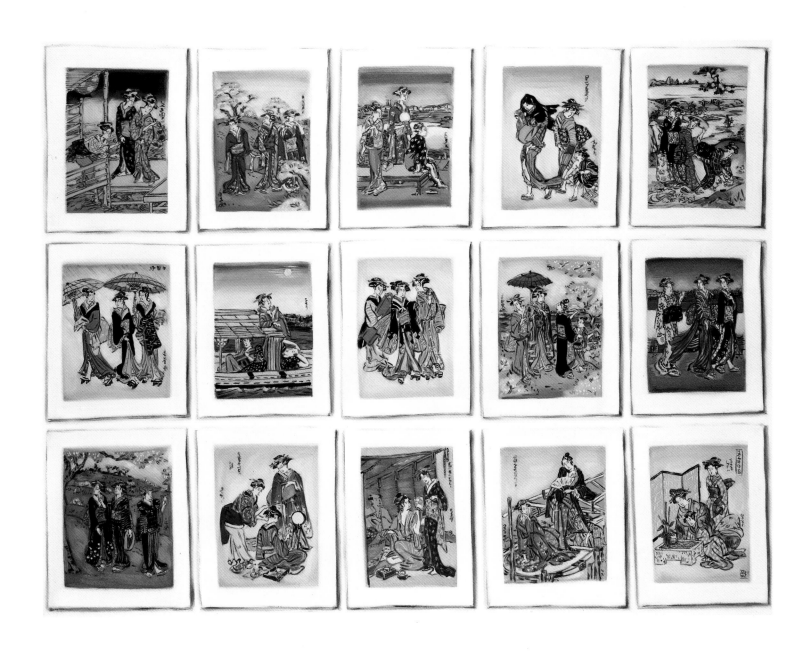

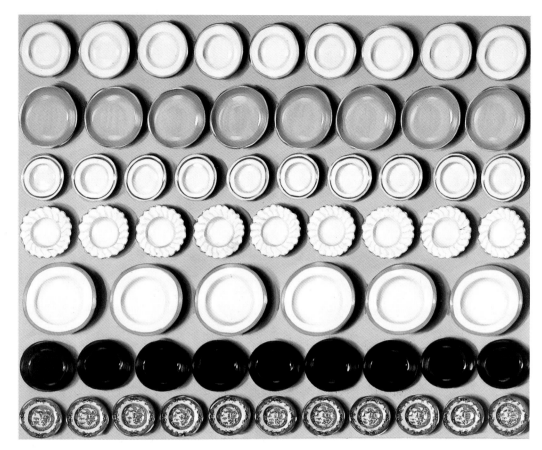

73 **Plates** 1992

74 **Plates** 1993

76 **Plates** 1992

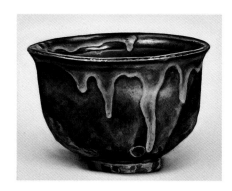 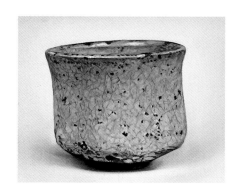

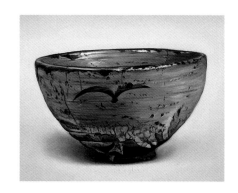 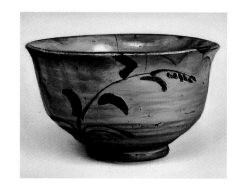

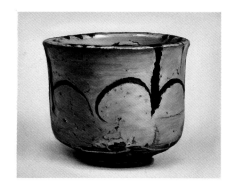 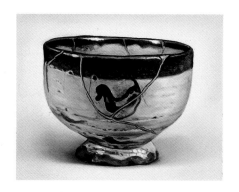

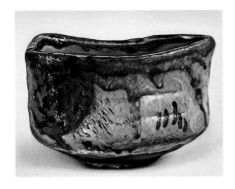

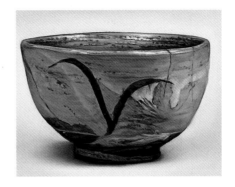

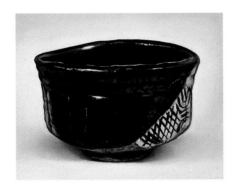

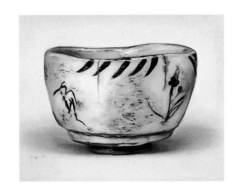

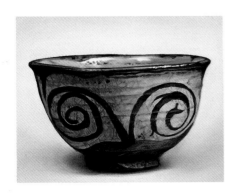

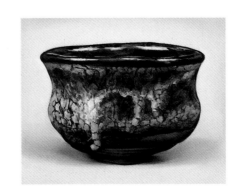

79 **Squares** 1991

81 **Squares** 1991

82 **Squares** 1991

83 **Ribbons** 1986

84 **Gold Braid** 1986

88 **Flowers** 1993

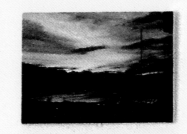
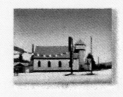

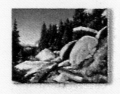

90 **American Holiday** 1995

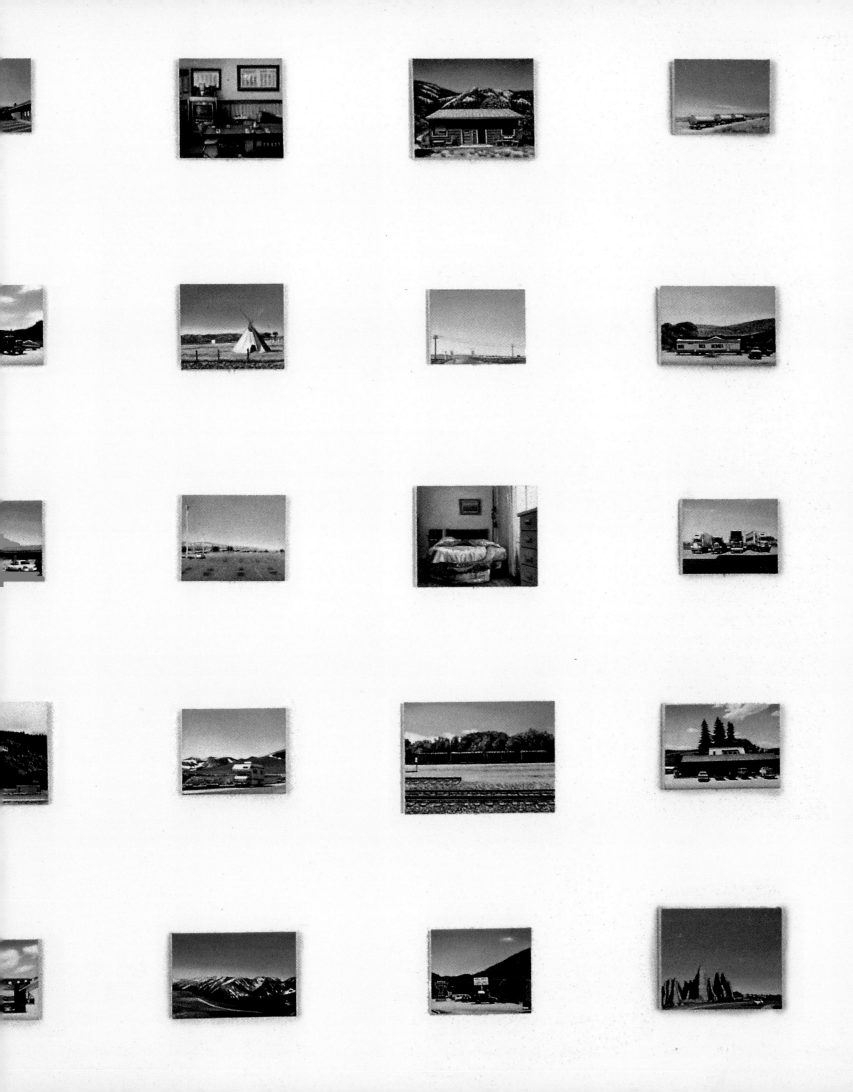

91 **Landscape** 1993

92 **Landscape** 1993

93 **Landscape** 1993

94 **Landscape** 1993

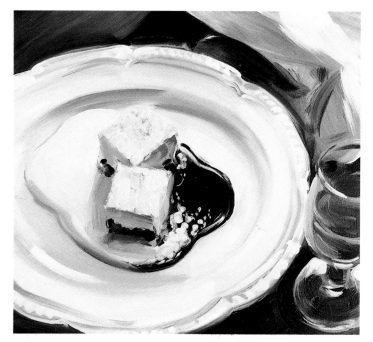

95 **Dessert** 1993

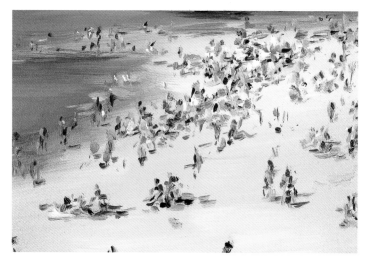

96 **Beach** 1993

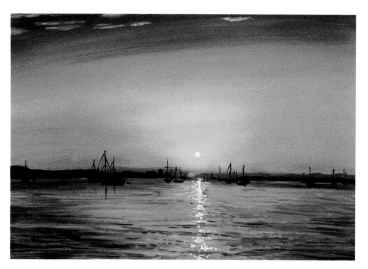

97 **Sunset** 1993

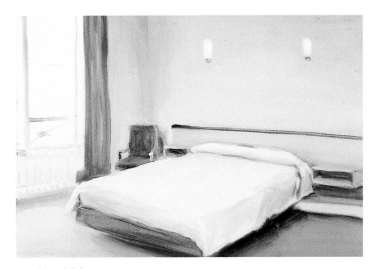

98 **Hotel Room** 1993

99 **Mountains** 1993

100 **Banquet** 1993

101 **Kyoto House** 1994

102 **Street** 1996

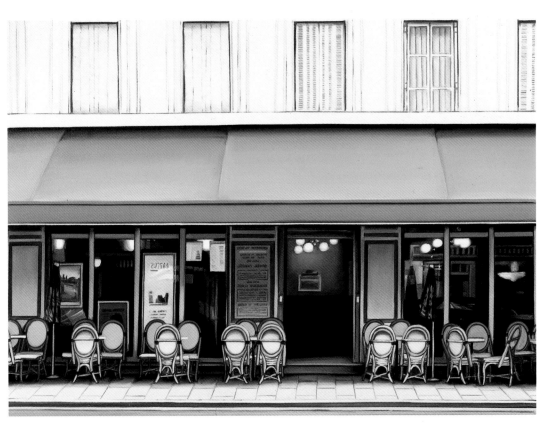

103 **Paris Café** 1996

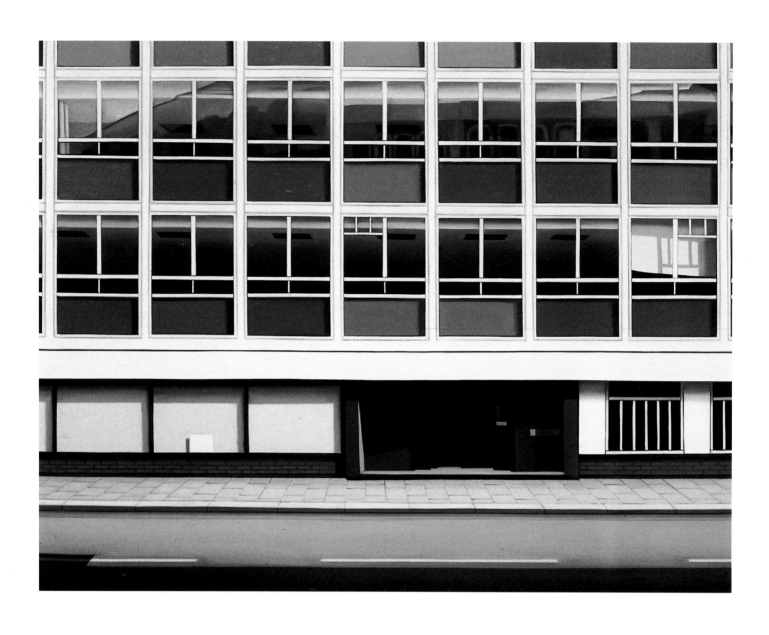

104 **Holborn** 1995

105 **Finsbury Square** 1995

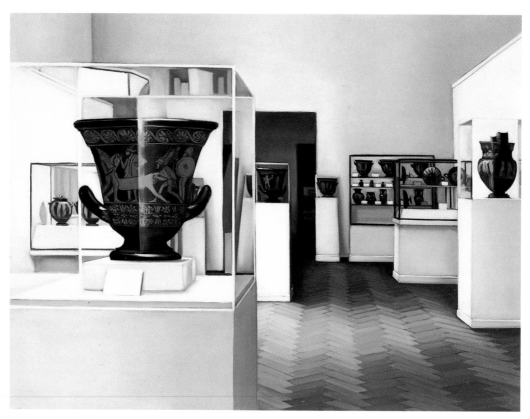

106 **Museum** 1996

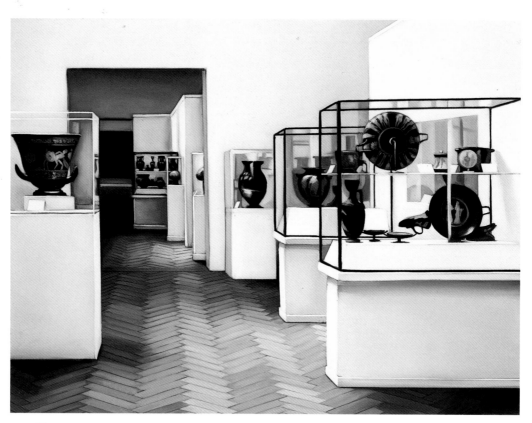

107 **Museum** 1996

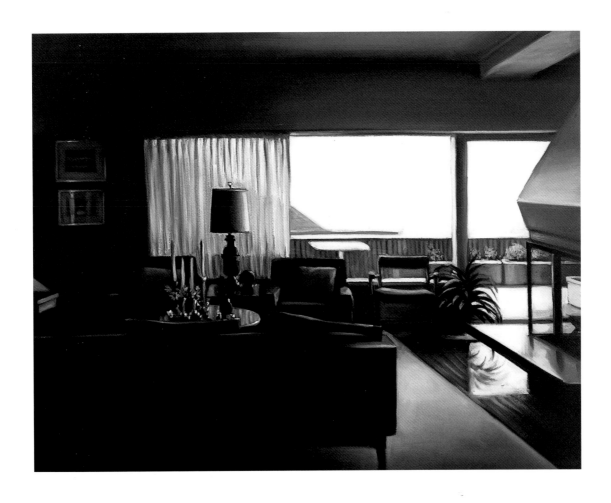

108 **Vancouver Living Room** 1994

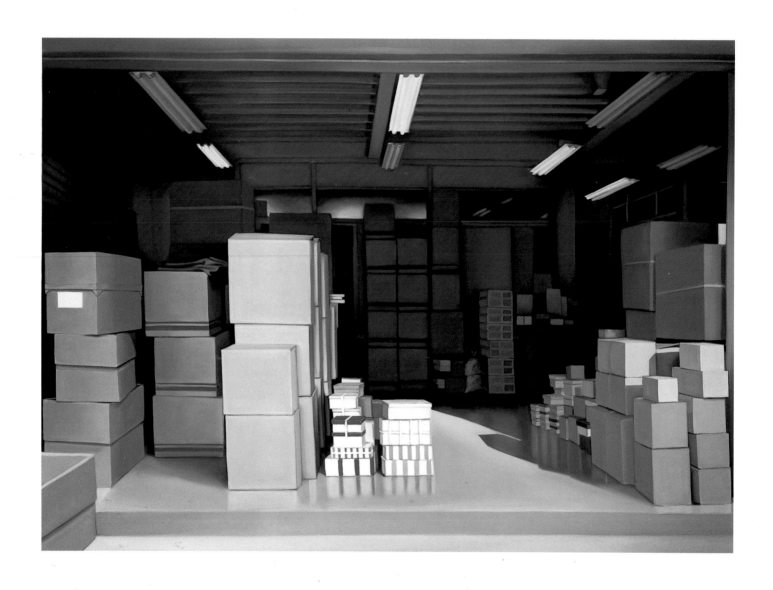

109 **Kyoto Warehouse** 1994

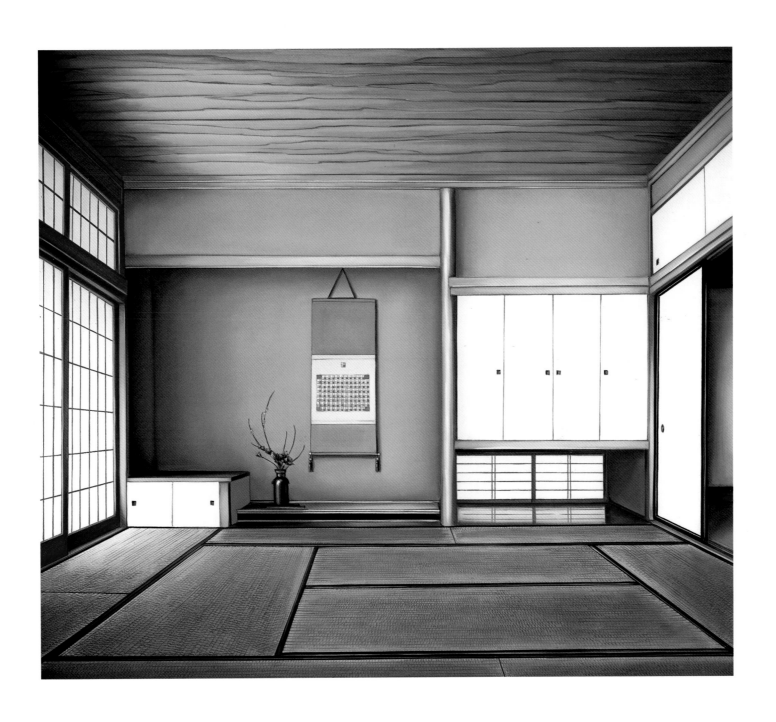

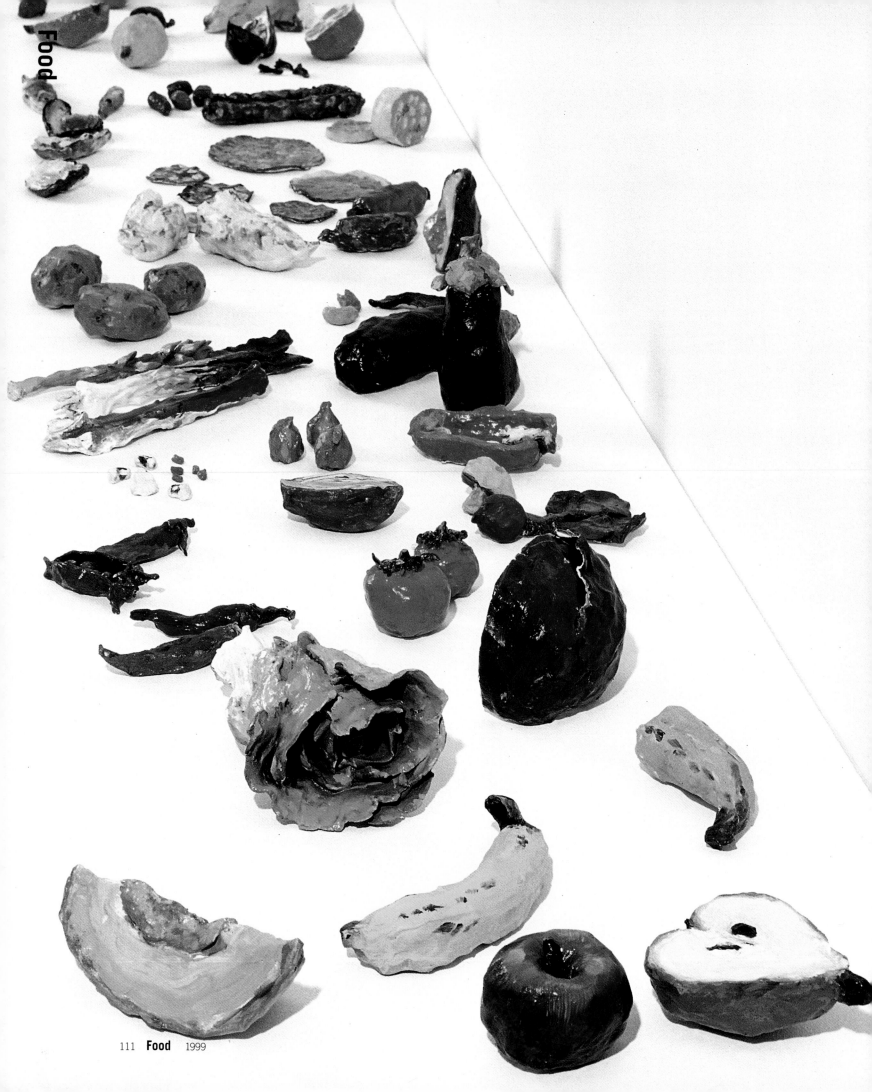

112 **Melons** 1986

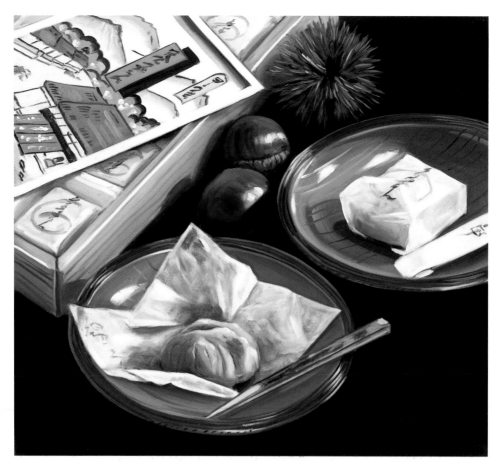

113　**Japanese Sweet**　1996 – 97

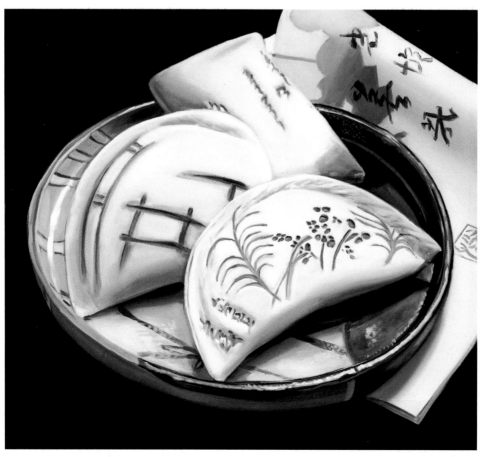

114　**Japanese Sweet**　1996 – 97

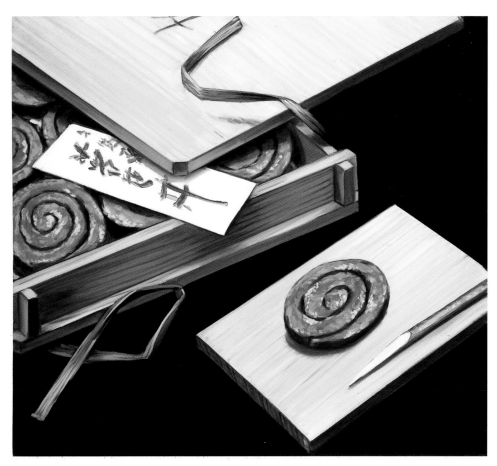

115 **Japanese Sweet** 1996 – 97

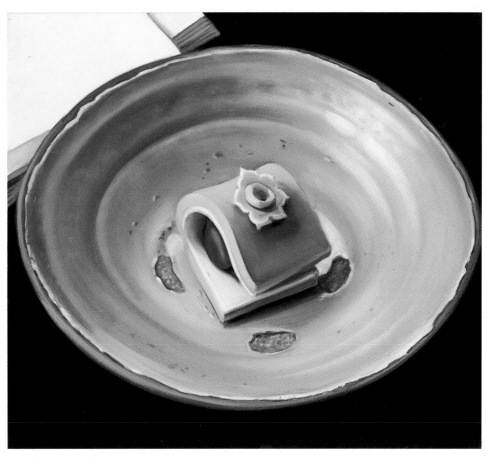

116 **Japanese Sweet** 1996 – 97

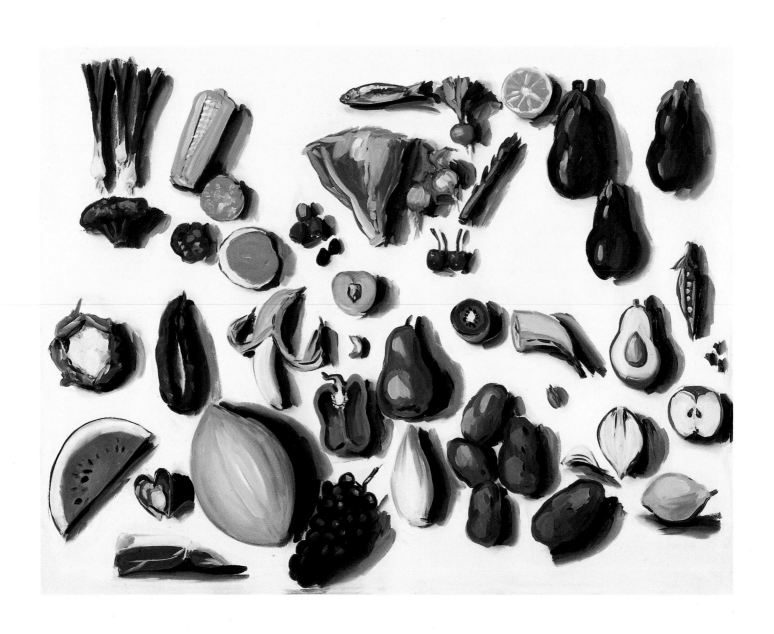

117 **Fruit and Vegetables** 1999

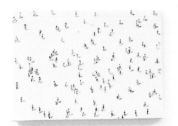

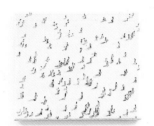

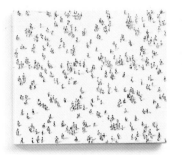

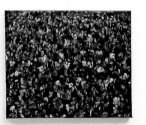

120 **Crowd** 1992

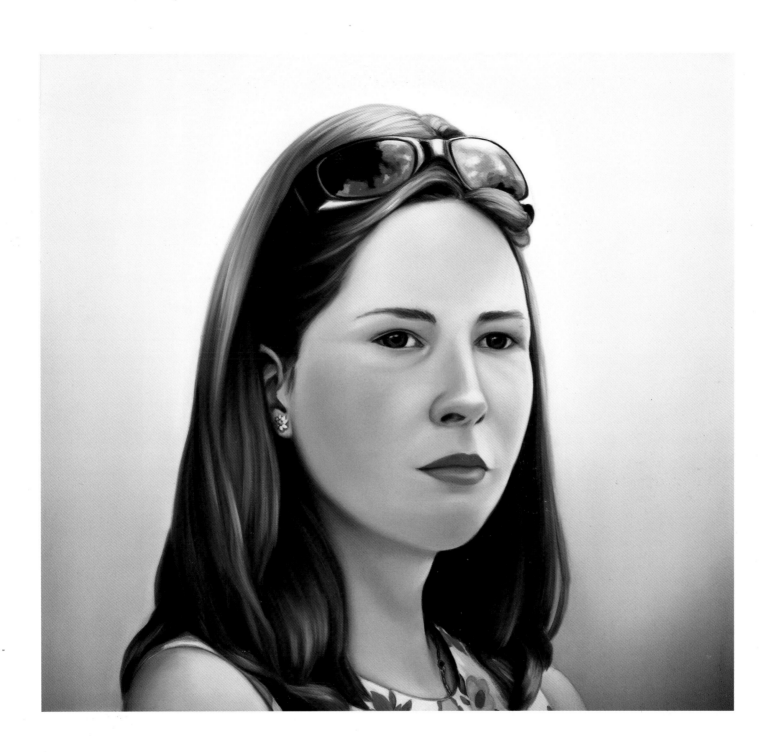

119 **Girl with Sunglasses** 1998

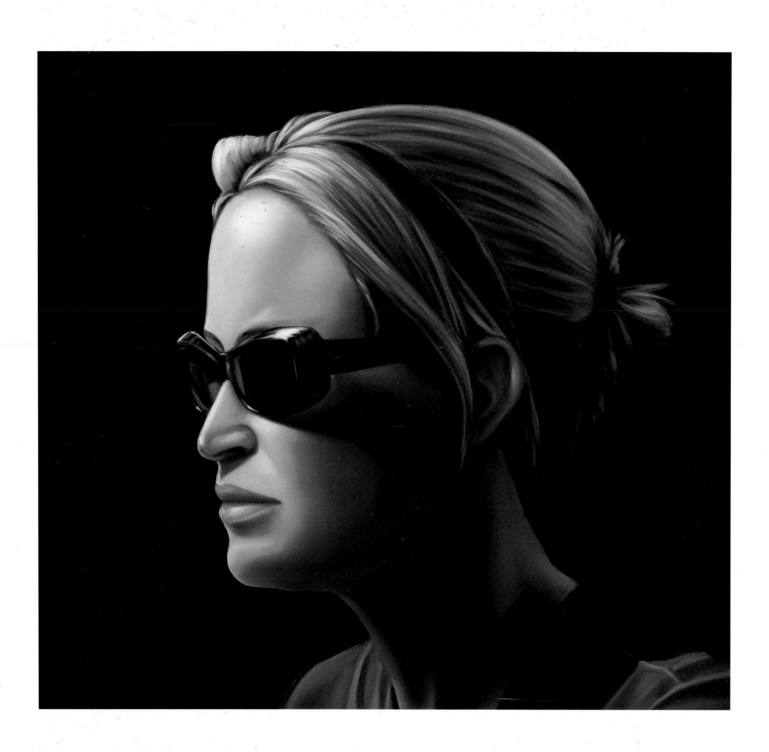

121 **Girl** 1998

123 **Heneage** 1997

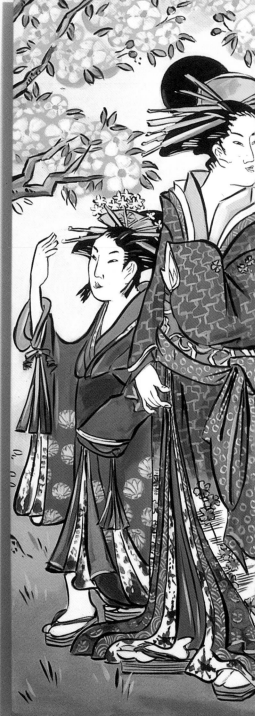

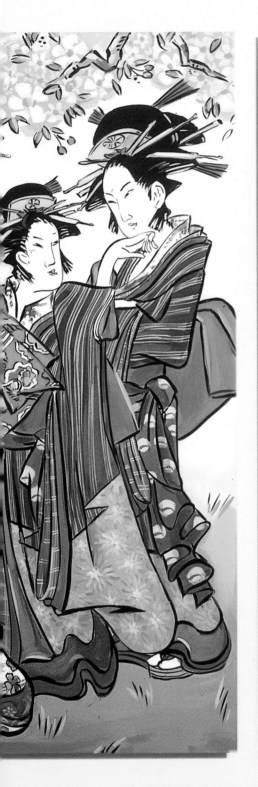
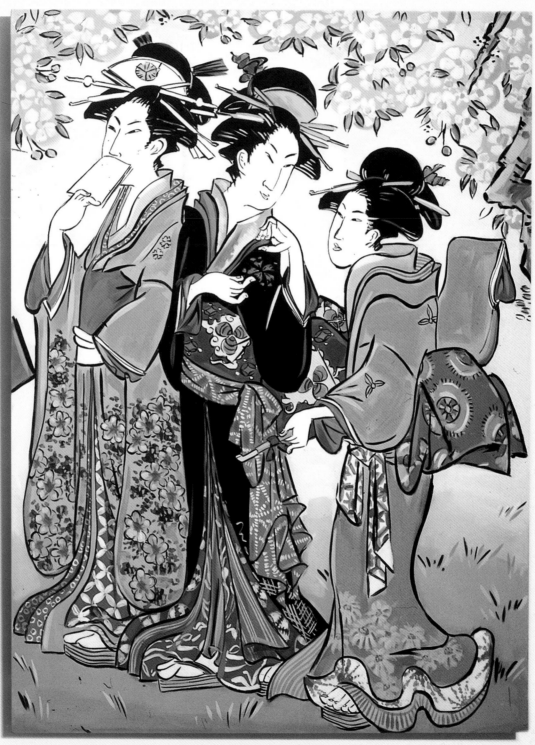

126 **Did You See That?** 2000

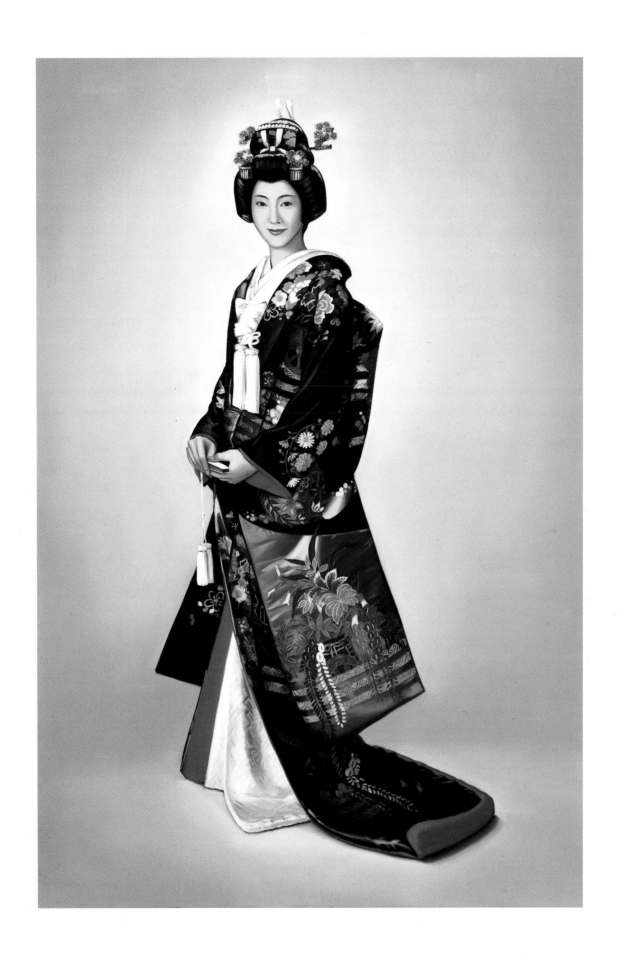

127 **Kimono** 1996

128 **This Painting was Based on a Canadian Calendar,
But I was Also Thinking of My Friend David's Farm** 1999

129 **Waterfall** 1999

 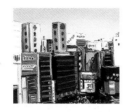 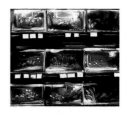

 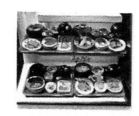 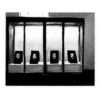

 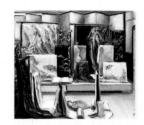

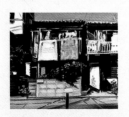 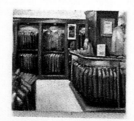 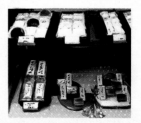

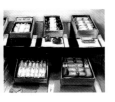

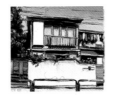
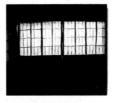
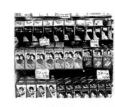

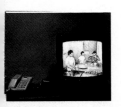

131 **Seven Views of Marunouchi** 1998

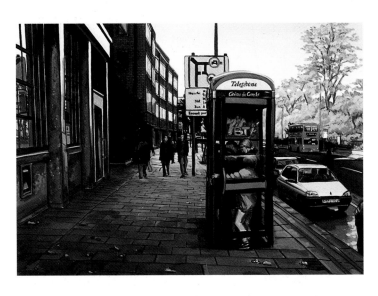
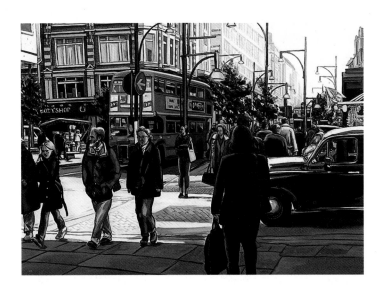

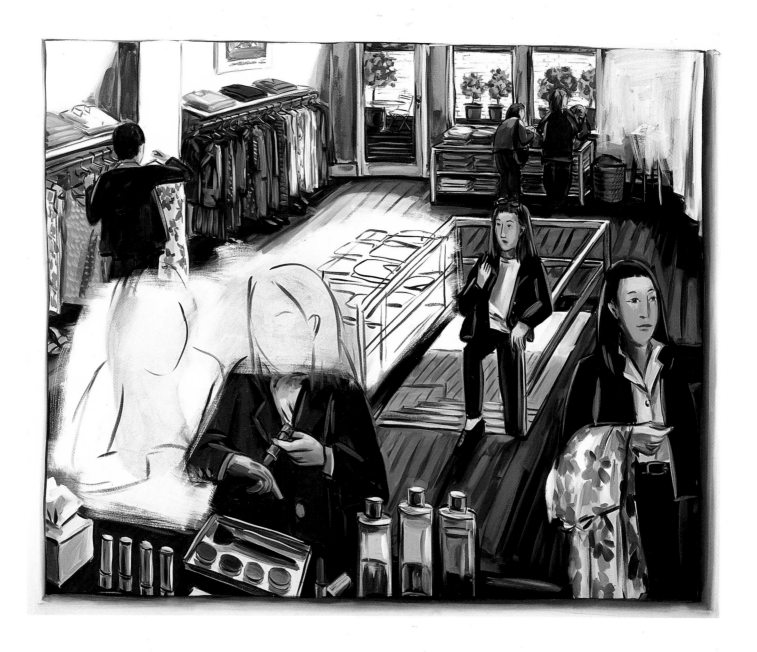

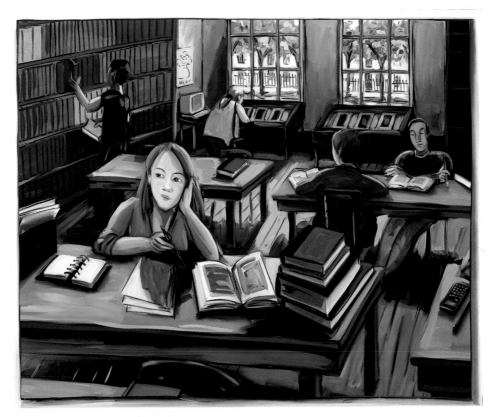

135 **In the Library** 2000

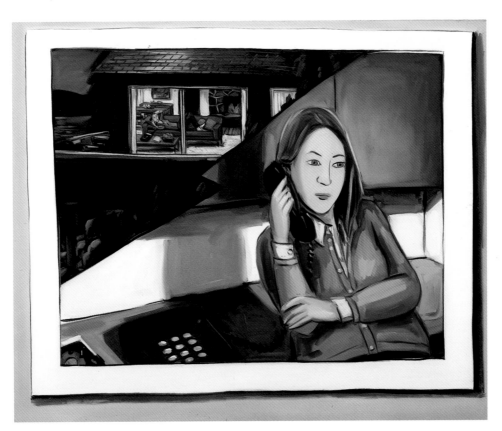

136 **Telephone Call** 2000

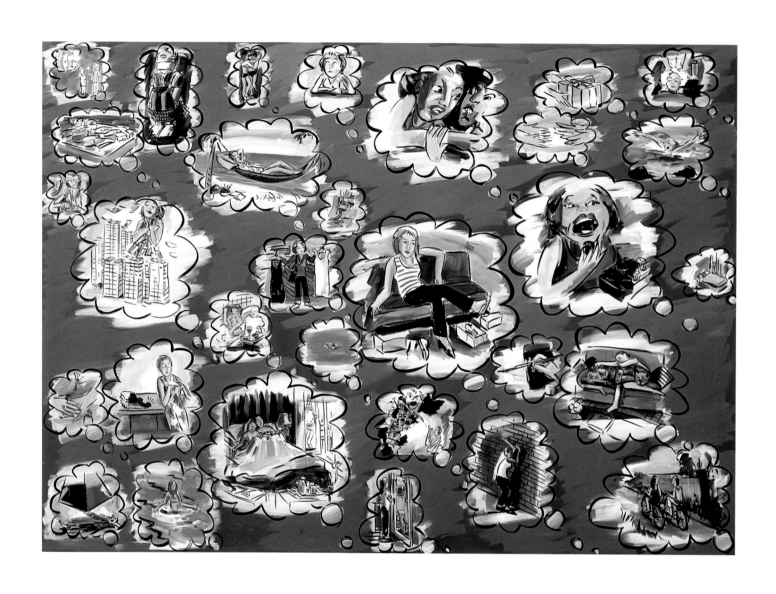

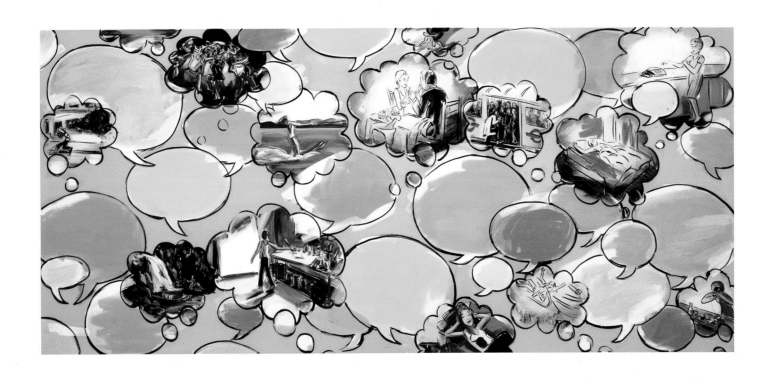

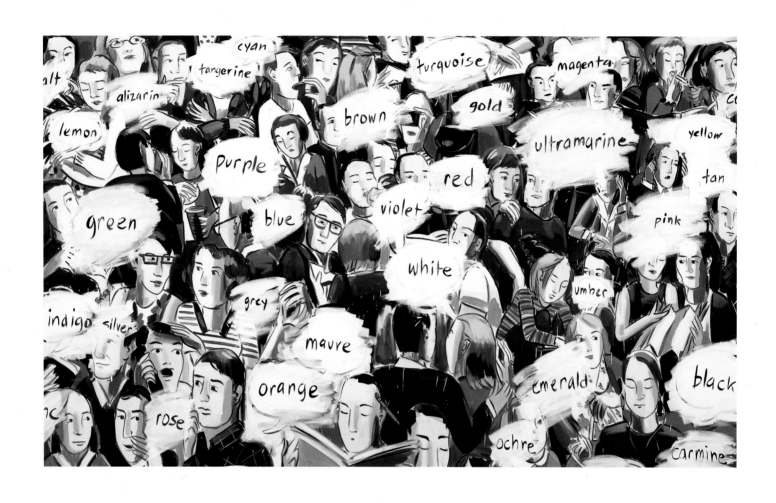

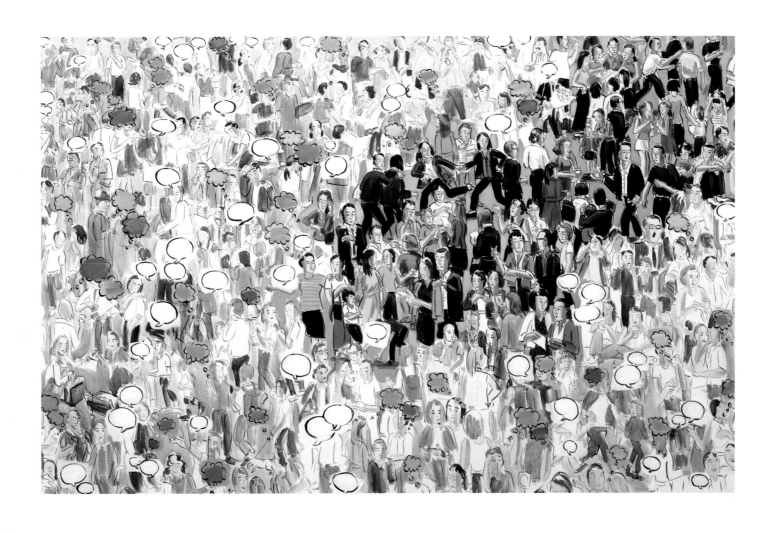

A Jukebox for Lisa Milroy
Jean-Pierre Criqui

Begin the Beguine

Recently, in the course of a night spent reading a wide variety of subjects and genres in a bid to beat insomnia, I dreamt – not without a pleasant feeling of surprise, tinged perhaps with a certain sense of relief – that the job of the art critic was no longer to produce a written text but to compose a mosaic of musical pieces which, owing to an alchemical process whose value largely depended on its inexplicable, or at least unexplained, nature, would mirror the works I had to discuss. (To the hypocritical reader, who may want to pin me down on his/her little mental couch, to shoot me down in flames, I will simply say that I had no personal involvement in this music, which was merely taken from the shelves of my record collection. This, and the fact that these were all very well-known compositions or performances, should be enough to quash any petty allusion to the idea of the critic as a failed artist. Any other theory, of course, is fair game.) As everyone knows, life is but a pale reflection of our dreams: so the list of tunes below is accompanied by a short text. It is a sad fact, but we always have to apologise for talking about painting.

I Could Write a Book

But is this fair? Just as the history of art has always incorporated the history of its endings, as if it formed a type of narrative running parallel to that of its changes – whether we consider the opening of Book XXXV of Pliny's *Natural History*, and his thoughts on the obsolescence of painting, 'art renowned long ago'; or Poussin's judgement on Caravaggio, who was born 'to destroy painting'; or the many laments elicited by the invention of photography; or the Neo-Plasticism created by Mondrian, whose apotheosis would have been to merge with his everyday surroundings, and many other projects whose main aim seems, 'ultimately', to have been to prolong the existence of the art of painting – I am invariably struck by the way in which commentaries on paintings seem to hover around an obscure core of silence, a desire for silence which can probably only find expression in and be denoted by the written word. When all is said and done, this may be the only real function of the art critic: to endeavour – in vain, but this futility only becomes apparent after the event – to exhaust what can be said about art and in this way to keep appealing to the silence which, without words, would have no justification. We can learn a great deal from the example of Félix Fénéon, who was unanimously regarded as an exceptional critic: what he was actually painstakingly doing with a body of very short, polymorphic and sometimes anonymous texts, as well as his taste for what he called 'indirect work' (editing other people's texts, encouraging relationships between his many friends and relations), was trying to eliminate, eradicate his identity as an author. In addition, he wrote less and less and ended his life in seclusion, fulfilling the prophesy of Alfred Jarry who, in the *Almanach du Père Ubu*, published in 1899, had used a neologism to describe him: 'celui qui silence' (he who silences). Consequently, a Bartleby who does not know

himself, or who prefers not to be too aware of his true nature, can serve as a double for critics who are superficially more confident. In 1955, when writing an 'Autobiographical Statement' for publication in an encyclopaedic work, Clement Greenberg himself concluded in these rather ambivalent terms: 'Art criticism, I would say, is about the most ungrateful form of "elevated" writing I know of. It may also be one of the most challenging – if only because so few people have done it well enough to be remembered – but I'm not sure the challenge is worth it'.

Such is my frame of mind when I think about Lisa Milroy's paintings which, it seems to me, represent a particular type of challenge for the spectator. These works are *likeable* at first sight and therefore straightaway provoke some kind of feeling of distrust, since modern art in general has taught us to be wary on principle of anything which immediately appeals to us. This is also because, if we elect to contemplate or consider one or other of the paintings for slightly longer, it seems that this approachability, this accessibility, this spectator-friendly quality coupled with the laid-back way in which they have become part of the history of art by appearing to be eminently contemporary, gradually gives way to an unfathomable profundity. The paintings are thus transformed into complete enigmas.

Dat Dere

What is it like to be a zebra? This work, *Zebra*, painted by Lisa Milroy in 1998, is placed in front of an idealised background and on an idealised floor which transform the painting into an extensive study in black and white. The slender shadows projected by the zebra's body form a vague anamorphosis of its bicolored coat, as if it has bled onto the bare, insubstantial décor into which it has unexpectedly been dropped (the strong back lighting is reminiscent of a scene in a studio, but one in a Criminal Records Office rather than at a fashion shoot). Its single eye makes no appeal to any external dimension, which helps to seal this image off from the outside world: this is not *a* zebra or *this* zebra caught at a precise moment in time or in a specific setting, but *the* zebra as the representation of an awareness of selfhood destined to remain eternally alien or incomprehensible to us. We will never know what it is like to be a zebra. We ourselves have viewed the animal in a variety of different ways. The people of the Middle Ages regarded it as a wild donkey which was black with white stripes and an extremely ugly, eminently diabolic, beast. In the Enlightenment, the French naturalist, Buffon, believed it to be a white horse with black stripes and the handsomest creature in Creation. As a result, this painting, which is the absolute epitome of the 'abstract painting with a figurative subject' genre (*pace* Bustos Domecq), largely refers back to its spectator and the latter's gaze. There is nothing like the combination of otherness and proximity afforded by the animal condition to encourage us to delve deep into the origins of our own singularity. The *Exhibition of a Rhinoceros at Venice*, painted around two centuries ago by Pietro Longhi and now kept at the Ca' Rezzonico in Venice, wonderfully illustrates this point by focusing our real attention on the members of the audience – men and women, adults and children, masked and unmasked – who have come to marvel at this unbelievable perissodactyl (it was not yet called a rhinoceros then), and who are placed facing us in the painting. Lisa Milroy finally abandons us to our memories of museums or illustrated books in this work. I think of Stubbs, but also Bridget Riley. (On 23 October 1907, in a letter to his wife Clara, Rilke described a self portrait by

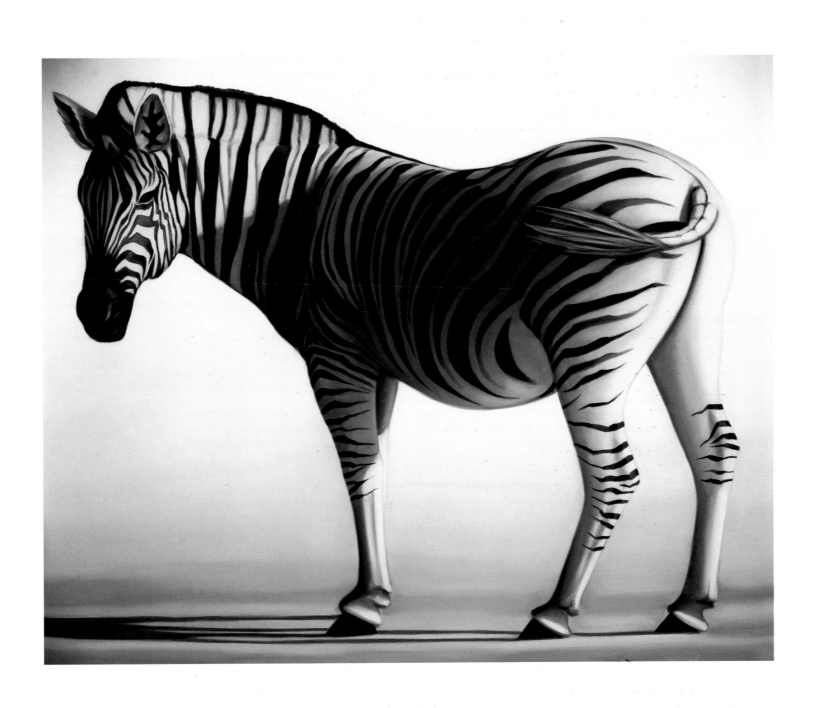

142 **Zebra** 1998

143
Tea Objects
1997

Cézanne painted around 1875 against a decorative background, referring to the 'steady animalistic attentiveness in the eyes, uninterrupted by any blinking of the eyelids, a constant air of watchfulness'. He added: 'And the grandeur and incorruptibility of this observant gaze are strengthened in an almost touching manner by the fact that he has depicted himself without endeavouring at all to interpret his expression or give himself a superior air, with so much humble objectivity, with the innocent good faith and plain inquisitiveness of a dog who, catching sight of itself in the mirror, thinks: "There's a dog!"')

Baubles, Bangles and Beads

The careful orthogonality which characterises the surface of *Small Objects* (1987) clearly shows the influence of abstract geometric painting. But the small items that can be seen in it also make it an heir to the long tradition of still life and, more accurately, of the technique of *rhopography* which, again owing to Pliny, remains associated with the name of Piraikos, whose fortune seems to have risen in inverse proportion to the value of what he elected to paint. Reflecting the same contradictory tension, the way in which Lisa Milroy's painting lends itself to interpretation as a horizontal plane prompts us to draw analogies with a typical feature of 20th century art – what Leo Steinberg has called 'the flatbed picture plane' – as well as with the mosaic floors of antiquity, beginning with the one by Sosos of Pergamum known as the 'unswept floor', which is scattered with the *trompe-l'oeil* leftovers of an imaginary meal. Milroy's 'small objects' include a certain number of introspective elements, whether

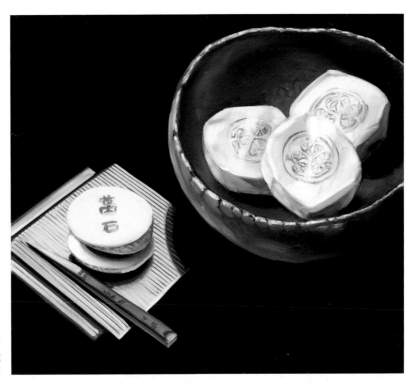

144
Japanese Sweet
1996–97

they refer to the artist's craft (brush, lead pencil, coloured pencil, slide), or whether they are perhaps numbered among her personal belongings. The painting takes a casual sideswipe at 'grandeur', representing a playful and not too heavy-handed snub directed at the temptations of drama and pomposity. She does not mock the painting itself at all, however, nor does she at any time deny the pleasure of painting, that keen appetite for art (irony and hedonism combining as they were wont to do, for example, in the work of James Ensor, Domenico Gnoli or in the later works of Philip Guston).

Ah! So

Although the close relationship between sight and sound, or between sight and touch, has often been discussed, and although some people have even suggested that the act of painting might involve a type of olfactory addiction (because of the turpentine), there have been few theoretical debates about the links between art and the sense of taste. However, who has not found their mouth watering in front of certain paintings? Lisa Milroy has used gustatory metaphors before now to comment on her work although, it should be stressed, not with regard to images of food. In an interview given to Richard Wentworth in 1990, published under the title 'In Order', she commented with regard to *Sailors' Caps*, a canvas of 1985: 'I wanted to exhaust an appetite for both making a certain kind of sweeping mark across the canvas that seemed entirely to do with the sailors' caps and the sailors' caps themselves. Like eating, one bite of something delicious never seems enough, and you want to renew or have

the experience again. (…) If there's a voluptuousness, it's in terms of paint'. The art of painting can therefore approach the realm of taste by means of its different *practical* methods (the French speak of the *cuisine* of such-and-such a painter), and the series of Japanese pastries executed by Milroy in 1996–97, as well as making your mouth water, is fascinating because of the wide spectrum of processes – abstract processes which can be transferred from one field to the other – that are apparent in her motifs: coating, stuffing, superposing, binding, glazing, dusting, etc. (In the *Empire of Signs*, Barthes noted that there is a *touch* associated with Japanese food.) We could also take a fresh procedural or constructivist look at the many delights found in the history of still life: the tubular wafers in the *Dessert de Gaufrettes* by Lubin Baugin, the inflatable structure of Chardin's *La Brioche*. This also brings us on to sculpture or architecture, the latter having provided Milroy with another major theme in her work.

You and the Night and the Music

Besides the somewhat frustrating miniaturisation of this object – the stuff of fantasy and desire – which reproduces recorded music, the advent of the CD has deprived us of the deep and lustrous black of vinyl records. *Records* (1988) has preserved its distinctive shine – crow's wing, Brylcream – and, in line with the type of shift we highlighted above, takes an object used for listening to music and uses it as a pretext for a meditation on the physical world. It would take a Riegl to recreate the hypnotic nature of this imposing group portrait (it is as if they were still turning on an invisible turntable) which allows Milroy to give free rein to the disorientating powers of repetition.

Idle Moments

Sky (1997–98) is a post-photographic echo of the great skies in Romantic art (Constable, Friedrich), a knowing and deliberate reference to contemporary and somewhat *tongue-in-cheek* perpetuators of this tradition, which can only be continued in the second degree (Richter, Ruscha). This large vertical panel also seems to be a faithful image of that state of non-verbal thought in which those who practise art as well as those who look at it can be placed by a painting. It is an all-encompassing creative emptiness, described by Lisa Milroy in the above-mentioned interview when talking about her choice of subjects: 'that kind of information you absorb in idle moments, like trailing your fingers in water. Without even knowing it, you've cast out a kind of mental net'. This is the appeal of art, which causes us to become detached and attentive at the same time and overwhelms us like a sky filling our vision.

Let's Call the Whole Thing Off

'Signs of bad taste: being surrounded by too many objects, too many brushes on the writing desk, too many Buddhas on the domestic shrine, too many stones, plants and trees in the garden, too many children and grandchildren in the house, too many words when you meet someone, too many qualities flaunted in a votive text. But it does not upset me to see a large number of books in the bookcase on wheels and filth in the ashtray.' (Urabe Kenko, *Essays in Idleness*, 1330–1335)

Discography

As this is, to my knowledge, the first text on painting with a soundtrack, it would not have seemed complete without the following information. The dates refer to the year that the records were recorded, which may differ from that of their original release.

Begin the Beguine, a song by Cole Porter, performed by Ella Fitzgerald on her album *The Cole Porter Songbook*, Volume One, 1956, Verve. I also listened to the instrumental version by the Art Pepper Quartet on *The Art of Pepper. The Complete Art Pepper, Aladdin Recordings, Volume Three*, 1957, Blue Note, and the one by pianist Misha Mengelberg's trio on *No Idea*, 1996, DIW.

I Could Write a Book, music by Richard Rodgers, lyrics by Lorenz Hart, features on Dinah Washington's record *For Those In Love*, 1955, Emarcy.

Dat Dere, Oscar Brown Jr. added the words to this theme composed by Bobby Timmons for its inclusion on his record, *Sin & Soul... And Then Some*, 1960, Columbia. This version was recorded by Sheila Jordan on *Portrait of Sheila*, 1962, Blue Note, and by Rickie Lee Jones on *Pop Pop*, 1991, Geffen.

Baubles, Bangles and Beads, by Wright-Forrest, is heard here in the performance by the Gerry Mulligan Quartet on *At Storyville*, 1956, Pacific.

Ah! So, a composition by Horace Silver, is the last track on the record by the Horace Silver Quintet entitled *The Tokyo Blues*, 1962, Blue Note.

You and the Night and the Music, Schwartz-Dietz, appears on *Vol. 3: The Octet No 2*, 1955, Contemporary, by Lennie Niehaus.

Idle Moments, composed by the pianist and arranger Duke Pearson and including a classic solo by Joe Henderson, gave its name to an album which Grant Green recorded for Blue Note in 1963.

Let's Call the Whole Thing Off is a song by the Gershwin brothers. Its performance by Mel Tormé and Marty Paich's 'Dek-tette' can be found on *Mel Tormé Sings Fred Astaire*, 1956, Bethlehem.

Such attention to detail demonstrates needlessly perhaps, some mistrust of the scholiasts of the future.

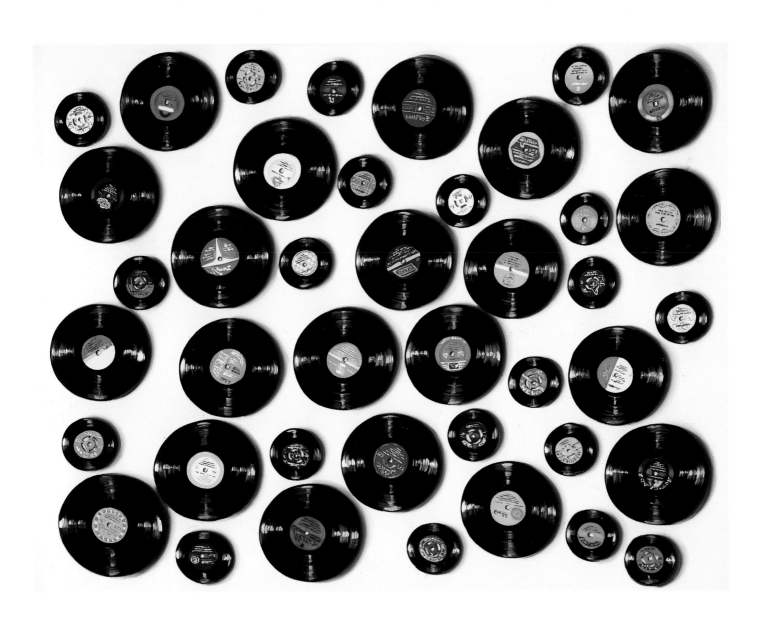

List of Illustrations

Dimensions in millimetres,
height before width

1
Student Geisha 1999
Oil on canvas
1397 × 1905
Waddington Galleries,
London

2
Shoes 1985
Oil on canvas
1765 × 2260
Tate
Presented by Charles
Saatchi 1992

3
Japanese Prints 1990
Oil on canvas
2030 × 2590

4
Scenes from a Life 1999
Oil on canvas
1778 × 3045
(With thanks to Sheila
Fraser) Waddington
Galleries, London

5
Sky 1997–98
Oil on canvas
2840 × 2030
Waddington Galleries,
London

6
A Day in the Studio 2000
Acrylic on canvas
1727 × 2160
Waddington Galleries,
London

7
Pulleys, Handles, Castors,
Locks and Hinges 1988
Oil on canvas
2030 × 2845

8
Small Objects 1987
Oil on canvas
1750 × 2130
Swindon Museum and
Art Gallery

9
Squares 1991
Oil on canvas
1980 × 2845

10
Kyoto House 1994
Oil on canvas
710 × 990

11
Kyoto House 1994
Oil on canvas
710 × 1030

12
Skirt 1984
Oil on canvas
Approx
1270 × 1040
Private Collection

13
Skirt 1984
Oil on canvas
Approx
1090 × 1420

14
Flowers 1984
Oil on canvas
Approx
660 × 965

15
Trilby 1983
Oil on canvas
Approx
300 × 390

16
Book 1983
Oil on canvas
710 × 915

17
Pyjamas 1984
Oil on canvas
915 × 710

18
Road Map 1983
Oil on canvas
1416 × 1040

19
Books 1984
Oil on canvas
710 × 870

20
Pile of Clothes 1983
Oil on canvas
Approx
760 × 1220

21
Fur Coat and Shoes 1984
Oil on canvas
2000 × 1420

22
Records and Shoes 1984
Oil on canvas
1800 × 1240

23
Four Vases 1984
Oil on canvas
1015 × 1220

24
Silverware 1984
Oil on canvas
660 × 915

25
Records, Vase and Book
1985
Oil on canvas
1942 × 2742

26
Personal Items 1984
Oil on canvas
1448 × 1803

27
Nine Books 1984
Oil on canvas
1905 × 1715

28
Four Books 1984
Oil on canvas
1230 × 1850

29
Books 1986
Oil on canvas
1750 × 2130

30
Books 1991
Oil on canvas
1930 × 2845

31
Dresses 1985
Oil on canvas
2077 × 3562

32
Shirts 1986
Oil on canvas
1879 × 1981

33
Underpants 1986
Oil on canvas
1750 × 2273

34
Regiment 1985
Oil on canvas
1830 × 2030

35
Sailors' Caps 1985
Oil on canvas
1910 × 2430
Courtesy Saatchi & Saatchi

36
Shoes 1985
Oil on canvas
1765 × 2265

37
Shoes (6 Rows) 1989
Oil on canvas
2030 × 2845
Private Collection

38
Shoes 1990
Oil on canvas
2030 × 2590

39
Shoes 1990
Oil on canvas
2032 × 2600
Waddington Galleries,
London

40
Shoes 1989
Oil on canvas
2030 × 2845

41
Shoes 1987
Oil on canvas
2030 × 2590

42
Light Bulbs 1988
Oil on canvas
2030 × 2845

43
Light Bulbs 1989
Oil on canvas
2030 × 2590

44
Light Bulbs 1991
Oil on canvas
2040 × 2600
Portsmouth City Museums
and Records Service

45
Light Bulbs 1988
Oil on canvas
2030 × 2845

46
Hardware 1991
Oil on canvas
1930 × 2490

47
Handles 1988
Oil on canvas
1905 × 2185

48
Hardware 1991
Oil on canvas
2030 × 2845
Private Collection

49
Tyres 1988
Oil on canvas
2210 × 3657

50
Tyres 1988
Oil on canvas
2030 × 2845

51
Tyres 1988
Oil on canvas
2030 × 2590
Courtesy Saatchi & Saatchi

52
Fans 1990
Oil on canvas
2030 × 2845

53
Fans 1986
Oil on canvas
2030 × 2590

54
Records 1989
Oil on canvas
2030 × 2590

55
Records 1987
Oil on canvas
2030 × 3045
Janice and David
Blackburn, London

56
Roman Coins 1985
Oil on canvas
1765 × 2025

57
Roman Coins 1986
Oil on canvas
1980 × 1880

58
Stamps 1988
Oil on canvas
2030 × 2845

59
Stamps 1990
Oil on canvas
2030 × 2590
Waddington Galleries,
London

60
Stamps 1986
Oil on canvas
1890 × 1980

61
Butterflies 1988
Oil on canvas
1830 × 2140

62
Butterflies 1986
Oil on canvas
1830 × 2220

63
Butterflies 1986
Oil on canvas
Approx
1830 × 2130

64
Rocks 1993
Oil on canvas
1524 × 2184

65
Rocks 1992
Oil on canvas
24 parts, each 665 × 665

66
Greek Vases 1990
Oil on canvas
2222 × 2845
Private Collection

67
Greek Vases 1990
Oil on canvas
2210 × 2845

68
Fragments 1987
Oil on canvas
2030 × 2590

69
Fragments 1989
Oil on canvas
2030 × 2845

70
Greek Vases 1989
Oil on canvas
2030 × 2845

71
Japanese Prints 1986
Oil on canvas
2290 × 1740

72
Japanese Prints 1989
Oil on canvas
1880 × 2438
Private Collection

73
Plates 1992
Oil on canvas
2030 × 2600
Waddington Galleries,
London

74
Plates 1993
Oil on canvas
1930 × 2590

75
Plates 1993
Oil on canvas
2030 × 2590

76
Plates 1992
Oil on canvas
2030 × 2590

77
Plates 1992
Oil on canvas
2184 × 1905

78
Tea Bowls 1999
Oil on canvas
12 parts each 380 × 455
6 are included in the
exhibition courtesy
Private Collection, Paris
and Waddington Galleries,
London

79
Squares 1991
Oil on canvas
1980 × 2845

80
Squares 1991
Oil on canvas
1930 × 2790
Mondstudio

81
Squares 1991
Oil on MDF
150 blocks,
each 63 × 63

82
Squares 1991
Oil on canvas
1930 × 2590
Courtesy Galerie Jennifer
Flay, Paris

83
Ribbons 1986
Oil on canvas
1923 × 2483

84
Gold Braid 1986
Oil on canvas
1778 × 2160

85
Lace 1993
Oil on canvas
1930 × 2490
Courtesy Galerie
Jennifer Flay, Paris

86
Wallpaper 1993
Oil on canvas
1625 × 1395

87
Wallpaper 1993
Oil on canvas
2030 × 1520
Private Collection,
Belgium

88
Flowers 1993
Oil on canvas
4 individual paintings,
each 1015 × 1015

89
Flowers 1999
Oil on canvas
1378 × 1378

90
American Holiday 1995
Oil on canvas
35 parts, each approx
230 × 330

91
Landscape 1993
Oil on calico
450 × 1029

92
Landscape 1993
Oil on calico
450 × 1029

93
Landscape 1993
Oil on calico
450 × 1029

94
Landscape 1993
Oil on calico
450 × 1029

95
Dessert 1993
Oil on polyester
280 × 305

96
Beach 1993
Oil on polyester
280 × 330

97
Sunset 1993
Oil on polyester
305 × 455

98
Hotel Room 1993
Oil on polyester
230 × 305

99
Mountains 1993
Oil on polyester
355 × 460

100
Banquet 1993
Oil on polyester
355 × 460

101
Kyoto House 1994
Oil on canvas
710 × 1030

102
Street 1996
Oil on canvas
960 × 1410

103
Paris Café 1996
Oil on canvas
1930 × 2590

104
Holborn 1995
Oil on canvas
1745 × 2280

105
Finsbury Square 1995
Oil on canvas
1755 × 2291
Tate
Presented by the
Patrons of New Art
(Special Purchase Fund)
through the Tate Gallery
Foundation 1996

106
Museum 1996
Oil on canvas
812 × 1092

107
Museum 1996
Oil on canvas
826 × 1219

108
Vancouver Living Room
1994
Oil on canvas
430 × 560

109
Kyoto Warehouse 1994
Oil on canvas
1380 × 1900

110
Room 1997
Oil on canvas
1753 × 1988
Tate
Purchased 1998

111
Food 1999
Oil paint on clay
Objects of various sizes
from 7 × 7 to 305 × 305
Courtesy Galerie Jennifer
Flay, Paris

112
Melons 1986
Oil on canvas
1778 × 2692
Southampton City Art
Gallery

113
Japanese Sweet 1996–97
Oil on canvas
476 × 527

114
Japanese Sweet 1996–97
Oil on canvas
387 × 438
Private Collection

115
Japanese Sweet 1996–97
Oil on canvas
476 × 527
Lent by Alan Cristea

116
Japanese Sweet 1996–97
Oil on canvas
387 × 438
Hester van Roijen

117
Fruit and Vegetables
1999
Oil on canvas
1384 × 1829
Waddington Galleries,
London

118
Fast Food 1999
Oil on MDF
6 parts, each 660 × 930
Debra Hauer and
Jeremy King

119
Girl with Sunglasses 1998
Oil on canvas
1070 × 1170

120
Crowd 1992
Oil on polyester
6 individual paintings,
each approx.
230 × 300

121
Girl 1998
Oil on canvas
1066 × 1167
Tate
Presented by the Friends
of the Tate Gallery 1998

122
Girl 1998
Oil on canvas
1905 × 1676
Deborah Davis

123
Heneage 1997
Oil on canvas
1240 × 1140
Private Collection

124
Charles 1997
Oil on canvas
1290 × 1110
Private Collection

125
Geishas 2000
Household gloss paint on
aluminium
3 panels,
each 1473 × 1987
Waddington Galleries,
London

126
Did You See That? 2000
Oil on canvas
1650 × 2030
Waddington Galleries,
London

127
Kimono 1996
Oil on canvas
2280 × 1600
Courtesy Galerie
Jennifer Flay, Paris

128
*This Painting was Based
on a Canadian Calendar,
But I was Also Thinking
of My Friend David's Farm*
1999
Oil on canvas
1960 × 2290
Collection of Ned Sachs
and Pat Aluisi

129
Waterfall 1999
Oil on canvas
1260 × 2768
Courtesy Galerie
Jennifer Flay, Paris

130
Tokyo 1994
Oil on polyester and calico
27 individual paintings,
each approx
240 × 350

131
*Seven Views of
Marunouchi* 1998
Household gloss paint
on MDF
7 panels,
each 1524 × 2030

132
London 1999
Household gloss paint
on MDF
12 parts,
each 1240 × 1775
Private Collection

133
In The Shade 1999
Household gloss paint
on aluminium
3 panels,
each 1473 × 1994
Waddington Galleries,
London

134
Shopping 2000
Oil on canvas
1650 × 2030

135
In The Library 2000
Oil on canvas
1650 × 2030

136
Telephone Call 2000
Oil on canvas
1650 × 2030
Waddington Galleries,
London

137
Pain or Pleasure? 2000
Oil on canvas
2030 × 2845
Waddington Galleries,
London

138
Thoughts and Words
2000
Oil on canvas
1650 × 3657
Waddington Galleries,
London

139
Memories 2000
Oil on canvas
1955 × 4673
Waddington Galleries,
London

140
To and Fro 2000
Oil on canvas
1980 × 3300
Waddington Galleries,
London

141
Doing Thinking Speaking
2000
Oil and acrylic on canvas
1930 × 3045
Waddington Galleries,
London

142
Zebra 1998
Oil on canvas
1657 × 2032
Courtesy John Studzinski

143
Tea Objects 1997
Oil on canvas
1092 × 1403
Barclay's Bank Collection

144
Japanese Sweet 1996–97
Oil on canvas
387 × 438
Collection of Sir Richard
Carew Pole

145
Painting a Picture 2000
Oil on canvas
1524 × 2235
Waddington Galleries,
London

146
Records 1990
Oil on canvas
2030 × 2590

Donations, Gifts and Sponsorships

The Trustees and Director of the Tate Gallery and The Director of Tate Liverpool are indebted to the following for their generous support:

Arrowcroft Group Plc
Arts Council of England
A & B (Arts & Business)
The Abbey National Charitable Trust
The Australian Bicentennial Authority
Barclays Bank PLC
The Baring Foundation
BASF
The Bernard Sunley Charitable Foundation
Bloomberg
Boddingtons plc
British Alcan Aluminium plc
BG plc
BT
Calouste Gulbenkian Foundation
Coopers & Lybrand
Mr & Mrs Henry Cotton
Cultural Relations Committee, The Department Of Foreign Affairs, Ireland
David M Robinson Jewellery

Deloitte & Touche
DLA
EC Harris
The Eleanor Rathbone Charitable Trust
The John Ellerman Foundation
English Partnerships
The Esmee Fairbairn Charitable Trust
European Arts Festival
European Regional Development Fund
The Foundation for Sport and the Arts
Friends of the Tate Gallery
Girobank plc
The Granada Foundation
Granada Television Limited
The Henry Moore Foundation
The Henry Moore Sculpture Trust
The Heritage Lottery Fund
Mr John Heyman
Higsons Brewery plc
Hitchcock Wright and Partners
Ian Short Partnership
IBM United Kingdom Limited
ICI Chemicals & Polymers Limited
The John Lewis Partnership

The John S Cohen Foundation
The Laura Ashley Foundation
The Littlewoods Organisation PLC
Liverpool John Moores University
Mr & Mrs Jack Lyons
Manchester Airport PLC
Manor Charitable Trust
Merseyside Development Corporation
Marconi
Mobil Oil Company
MOMART Ltd
The Moores Family Charitable Foundation
The Museums and Galleries Improvement Fund
Nigel Moores Family Charitable Foundation
NSK Bearings Europe Ltd
P & P Micro Distributors Ltd
Parkman Group Ltd
P H Holt Charitable Trust
The Pilgrim Trust
Pilkington plc
Pioneer High Fidelity (GB) Ltd
QVC The Shopping Channel
Rio Tinto plc
Royal & SunAlliance

Royal Liver Assurance Limited
Sainsbury Family Charitable Trusts
Samsung Electronics (UK) Limited
Save & Prosper Educational Trust
Scottish Courage Limited
Stanley Thomas Johnson Foundation
Shell Research Ltd
The Summerfield Charitable Trust
Tate Friends Liverpool
Tilney Investment Management
Trinity International Holdings plc
The TSB Foundation for England and Wales
The Trustees of the Tate Gallery
Unilever PLC
United Biscuits (UK) Limited
United Utilities plc
The University of Liverpool
Vernons Pools Ltd
Visiting Arts
Volkswagen
Whitbread & Company PLC
The Wolfson Foundation

Biography

Lisa Milroy was born in 1959, and raised in Vancouver BC. Although both her parents were born in Canada, she is of Scots-Irish ancestry on her father's side, and Ukrainian on her mother's. Lisa spent long summer holidays during her childhood in Manitoba where her maternal grandfather ran a general store.

Lisa lived for a year in Paris in 1978, working as an au pair and studying French at the Sorbonne before beginning a foundation course at St Martin's School of Art, London in 1979. She completed a BFA at Goldsmith's College in 1982, where Tony Carter, Michael Craig-Martin and Basil Beattie were her tutors.

Lisa worked with the Nicola Jacobs Gallery in the 1980s, and is currently represented by Waddington Galleries, London. She also works with Jennifer Flay in Paris, Luis Campaña in Cologne and Shoko Nagai in Tokyo, and has work in many private and public collections.

Solo Exhibitions

1984
Nicola Jacobs Gallery, London
Cartier Art Foundation, Paris (catalogue with essay by Stuart Morgan)

1986
Nicola Jacobs Gallery, London
Khiva Gallery, San Francisco

1988
Nicola Jacobs Gallery, London (catalogue with essay by Ian Jeffrey)

1989
John Berggruen Gallery, San Francisco
Third Eye Centre, Glasgow; touring to Southampton City Art Gallery; Plymouth Art Gallery (catalogue with essays by David Plante and Lynne Cooke)
Mary Boone Gallery, New York

1990
Kunsthalle Bern, Switzerland (catalogue with essay by Ulrich Loock and 'Lisa Milroy in conversation with Richard Wentworth, London, May 22 1990')

1991
Galerie Luis Campaña, Frankfurt
Modulo, Centro Difusor de Arte, Lisbon/Oporto

1992
Janner Gallery, Vienna
John Berggruen Gallery, San Francisco

1993
Waddington Galleries, London and Museum Schloss Hardenberg, Velbert, Germany (catalogue with essay by Julian Heynen)
Galerie Luis Campaña, Cologne
Galerie Jennifer Flay, Paris

1994
Gallery Shoko Nagai, Tokyo (catalogue with essay by Tatsumi Shinoda)
Kyoto City University of Arts

1995
The British School at Rome (exhibition broadsheet with essay by Mario Codognato)
Hotel Huger Cercle d'Art, La Flèche, France
Galerie de Expeditie, Amsterdam

1995–96
Chisenhale Gallery, London; touring to Ikon Gallery, Birmingham; Fruitmarket Gallery, Edinburgh (catalogue with essay by Max Wechsler)

1996
Galerie Patrick de Brock, Knokke, Belgium
Galerie Jennifer Flay, Paris

1997
Galerie Luis Campaña, Cologne

1998
Waddington Galleries, London (catalogue with essay
 by Elisabeth Lebovici)
Alan Cristea Gallery, London
Marunouchi Café, Tokyo

1999
Galerie Jennifer Flay, Paris
Galerie der Stadt Schwaz, Innsbruck

2000
Sadler's Wells Theatre, London
Alan Cristea Gallery, London (catalogue 'Alan Cristea
 Gallery 1999/2000')

2001
Tate Liverpool (catalogue with essays by Lewis Biggs,
 Fiona Bradley and Jean-Pierre Criqui)

Selected Group Exhibitions

1983
Charterhouse Gallery, London
'Young Blood', Riverside Studios, London

1984
'Problems of Picturing', Serpentine Gallery, London
(catalogue with essay by Sarah Kent)

1985
'John Moores Liverpool Exhibition 14', Walker Art Gallery,
Liverpool (prizewinner) (catalogue)

1986
'6th Sydney Biennale', Sydney (catalogue)
'Aperto', Venice Biennale
'Japonisme: Japanese Reflections in Western Art', Northern
 Centre for Contemporary Art, Sunderland (catalogue
 with essay by Marie Conte-Helm)
'Au Coeur du Maelstrom', Palais des Beaux-Arts, Brussels
 (catalogue with essay by K J Geirlandt)
'Objects As Art', Plymouth Arts Centre (catalogue with
 essay by Susan Butler)
'No Place Like Home', Cornerhouse, Manchester

1987
'Winter '87', Nicola Jacobs Gallery, London
'John Moores Liverpool Exhibition 15', Walker Art Gallery,
 Liverpool (first prize winner) (catalogue)
'Current Affairs: British Painting and Sculpture in the
 1980s', Museum of Modern Art, Oxford; touring to
 Mucsarnok, Budapest; Nemzeti Galeria, Prague; Zacheta,
 Warsaw (British Council exhibition) (catalogue with
 essay by Lewis Biggs)
'ART. Brittiskt 1980-tal', Liljevalchs Art Museum,
 Stockholm; touring to Sara Hildén Art Museum, Tampere,
 Finland as 'Britannia: Paintings and Sculptures from
 the 1980s' (British Council exhibition) (catalogue with
 essay by Lynne Cooke)

1987–88
'Three Artists from Britain', Jack Shainman Gallery,
 Washington DC and New York

1988
'Cries and Whispers: Paintings of the 1980s from the
 British Council Collection', touring Australia and New
 Zealand (catalogue with essay by Lewis Biggs, includes
 artist's statement)
'Winter '88', Nicola Jacobs Gallery, London
'The New British Painting', The Contemporary Arts Center,
 Cincinnati; touring to Chicago Public Library and Cultural
 Center; Haggerty Museum, Marquette University,
 Milwaukee, Wisconsin; Southeastern Center for
 Contemporary Art, Winston-Salem, North Carolina;
 Grand Rapids Art Museum, Michigan (catalogue with
 essays by Edward Lucie-Smith, Carolyn Cohen and
 Judith Higgins)

1989

Art of the '80s from the Collection of the Chemical Bank', The Montclair Art Museum, Montclair, New Jersey

'The Saatchi Collection at the Pierides Museum: Tony Cragg, Lisa Milroy and John Murphy', Pierides Museum of Contemporary Art, Athens (catalogue, includes artist's statement)

'Subject: Object', Nicola Jacobs Gallery, London

'John Moores Liverpool Exhibition 16', Walker Art Gallery, Liverpool (catalogue)

1990

'The British Art Show 1990', McLellan Galleries, Glasgow; touring to Leeds City Art Gallery; Hayward Gallery, London (catalogue with essays by David Ward, Caroline Collier and Andrew Nairne, includes artist's conversation with David Ward, November 1989)

'British Art Now: A Subjective View', Setagaya Art Museum, Tokyo; touring to Fukuoka; Nagoya; Utsunomiya; Kobe; Hiroshima (British Council exhibition) (catalogue with essay by Andrew Graham-Dixon)

Touko Museum of Contemporary Art, Nagoya

1991

'Out of Limbo', Fundaçion Luis Cernada, Seville

'Carnegie International 1991', The Carnegie Museum of Art, Pittsburgh, Pennsylvania (catalogue with essays by Mark Francis and Fumio Nanjo, includes artist's statement)

'Drawings', Mendelson Gallery, Pittsburgh, Pennsylvania

'La Couleur d'Argent', Musée de la Poste, Paris

'Goldsmiths' College Centenary Exhibition', selected by Richard Wentworth, Goldsmiths' Gallery, London, with Richard Wentworth, Grenville Davey and Gary Stevens (exhibition broadsheet with essay by Adrian Searle)

1992

'The Saatchi Gift', Tate Gallery, London

'Work from the British Collection', Calouste Gulbenkian Foundation, Lisbon

'Recent Acquisitions', Fukuoka Art Museum, Japan

1993

'Lisa Milroy, John Murphy: Paintings from the Saatchi Collection', Mead Gallery, University of Warwick, Coventry (exhibition broadsheet with essay by Barry Barker)

'Der Zerbrochene Spiegel/The Broken Mirror', Museumsquartier Messepalast and Kunsthalle Wien; touring to Deichtorhallen, Hamburg (catalogue with essay by Julian Heynen)

1994

'Cityscape', Monica de Cardenas, Milan

'Original Painting', Galerie Matisse, Institut Français, London, with Bernard Frize and Amikam Toren

1995

'Desenho Contemporaneo', Modulo, Centro Difusor de Arte, Oporto

'Life Patterns', Tate Gallery, London

'Ljubljana 21st International Biennale of Graphic Art', Ljubljana, Slovenia (catalogue)

'Contemporary British Art in Print', Scottish National Gallery of Modern Art, Edinburgh; touring to Yale Center for British Art, New Haven, Connecticut (catalogue with essays by Jeremy Lewison and Duncan Macmillan)

1996

'The Thinking Eye: An Exhibition by the Painting Faculty: The Royal College of Art', Gallery 7, Hong Kong (catalogue with essay by Paul Huxley)

'Craig-Martin, Davey, Fulton, McKeever, Milroy, Woodrow' (12 prints), Alan Cristea Gallery and The Paragon Press, London

'Theories of the Decorative', Baumgartner Galleries, Washington DC (exhibition broadsheet with essay by David Moos)

'Nouvelles Acquisitions du FRAC Franche-Comté', Musée des Beaux-Arts de Dole, France

'Pittura', Castello di Rivara, Italy (catalogue with essays by Paolo Fossati and Ursula Trübenbach)

'Home and Away', Tate Gallery Liverpool

'Loup y es tu?', Galerie du Frac, Montpellier

1996-97

'Classifictions', Galerie Art & Essai, Université de Rennes, France; touring to École Nationale Supérieure des Beaux-Arts, Paris (catalogue with essay by Emmanuelle Baleydier, Sandrine Léon and Sachiyo Nagasawa)

'Something to Say…', Wolverhampton Art Gallery and Museum

1996-98

'About Vision: New British Painting in the 1990s', Museum of Modern Art, Oxford; touring to Fruitmarket Gallery, Edinburgh; Wolsey Art Gallery, Ipswich; Laing Art Gallery, Newcastle-upon-Tyne (catalogue with essay by David Elliott)

1997

'Treasure Island', Calouste Gulbenkian Foundation, Lisbon (catalogue with essay by Jorge Molder and Rui Sanches)

'Tokyo International Forum Artwork Collection', Tokyo Metropolitan Forum (catalogue)

1998

'Portrait - Human Figure', Galerie Peter Kilchmann, Zurich

'Voyage, De l'Exotisme Aux Non-Lieux', Le Musée de Valence in association with FRAC Rhône-Alpes, France catalogue with essay by Yannick Miloux)

'Paved with Gold', Kettle's Yard, Cambridge (catalogue with essay by Simon Wallis)

'Urban', Tate Gallery Liverpool

'Modern British Art', Tate Gallery Liverpool

'Up to 2000', Southampton City Art Gallery

'Every Day', Biennale of Sydney (catalogue with essay by Simon Grant)

'Thinking Aloud', curated by Richard Wentworth, Kettle's Yard, Cambridge; touring to Cornerhouse, Manchester; Camden Arts Centre, London catalogue with essay by Nick Groom)

'Collection Nomade, Les Oeuvres Du Frac Franche-Comté Au Maroc', Institut Français, Bab el Kebir, Galerie Allal El Fassi, Rabat and Institut Français, Kenitra, Morocco; touring to Institut Français, Casablanca; Institut Français, Meknès et Fès (catalogue with essay by Valérie Pugin)

1999

'Un Art Incertain Du Réel: La Collection Du Frac Franche-Comté', Frac Bretagne, Châteaugiron, France'

'Presence: Figurative Art at the End of the Century', Tate Gallery Liverpool

'Go Away, Artists And Travel', Royal College of Art, London

'Artist's Tale', commissioned to design one of four Royal Mail Millennium Stamps

1999-2000

'Flower Show', The Fruitmarket Gallery, Edinburgh

2000

'Brave New World', Galerie Jennifer Flay, Paris

Public Collections

Arts Council of Great Britain
British Council
Calouste Gulbenkian Foundation, Lisbon
Chemical Bank, New York
Contemporary Art Society
Deutsche Bank Collection
Fonds Nationals d'Art Contemporain, France
Fonds Régional d'Art Contemporain de Franche-Comté, Dole, France
Fonds Régional d'Art Contemporain Provence Alpes Côte d'Azur, France
Fonds Régional d'Art Contemporain Rhône-Alpes, France
Fukuoka Art Museum, Japan
Metropolitan Museum of Art, New York
Nagoya City Art Museum
Nottingham Castle Museum and Art Gallery
Portsmouth City Museum
Southampton City Art Gallery
Swindon Museum and Art Gallery
Tate
Thorn EMI
Tochigi Art Museum, Japan
Tokyo Metropolitan Art Collection
Unilever Plc.
Wolverhampton Art Gallery and Museum